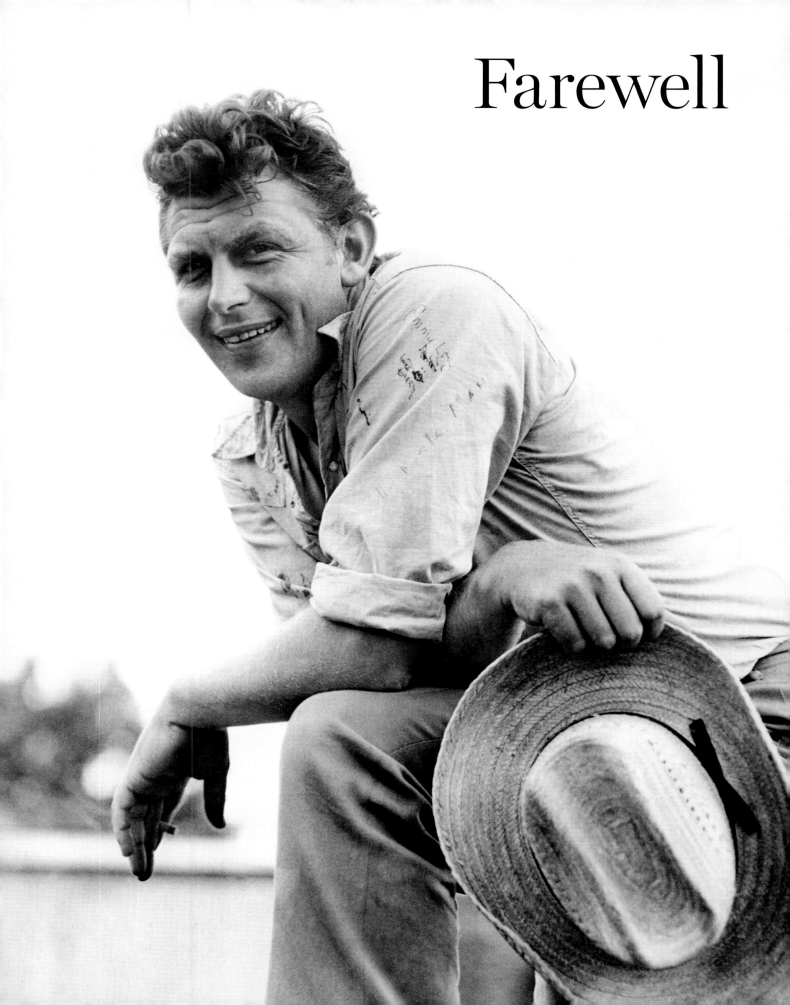

Farewell

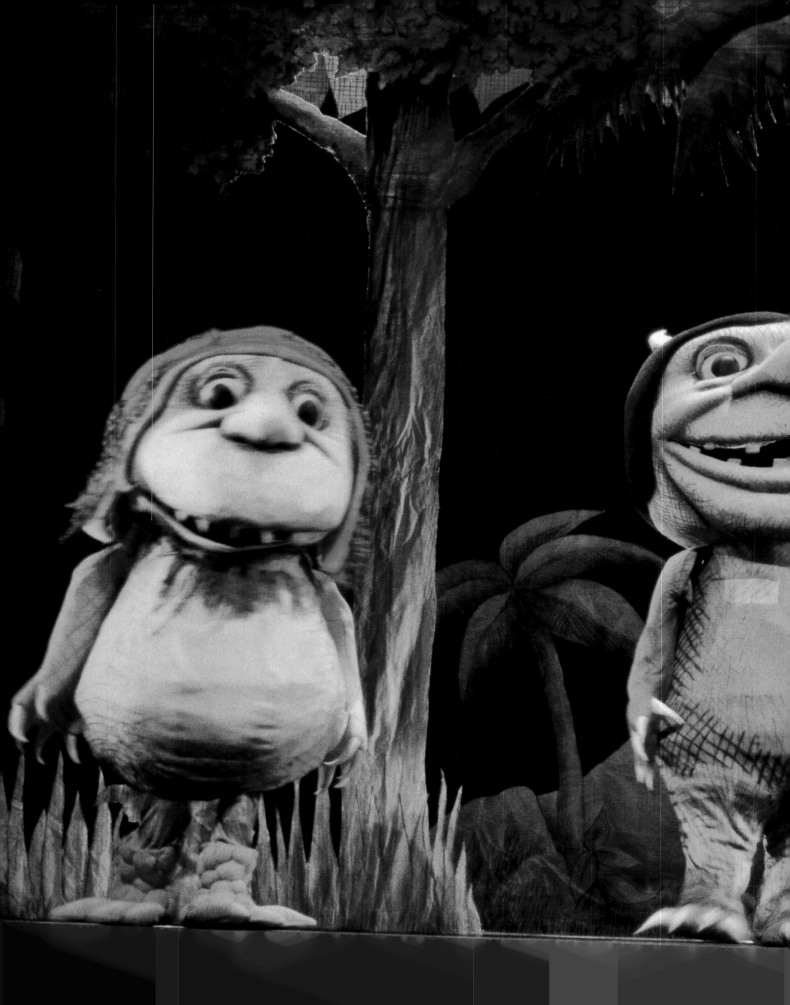

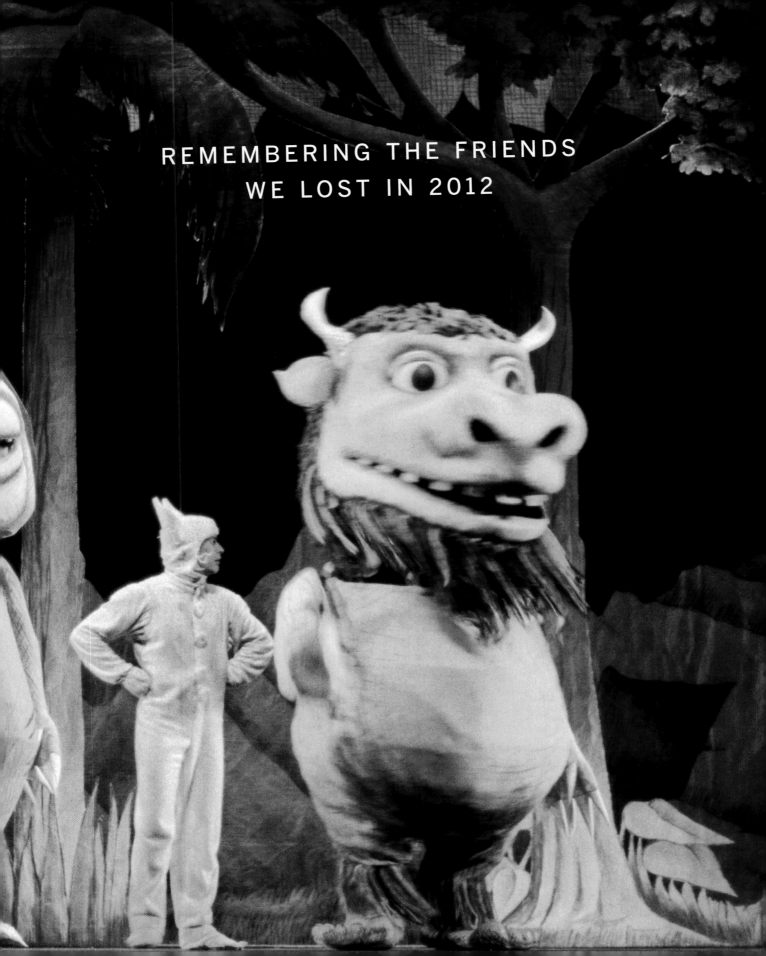

REMEMBERING THE FRIENDS
WE LOST IN 2012

LIFE BOOKS

Managing Editor
Robert Sullivan

Director of Photography
Barbara Baker Burrows

Creative Direction & Design
Li'l Robin Design, Inc.

Deputy Picture Editor
Christina Lieberman

Copy Chief
Parlan McGaw

Copy Editor
Barbara Gogan

Writer-Reporters
Kathleen Brady, Michelle DuPré,
Marilyn Fu, Amy Lennard Goehner

Photo Associate
Sarah Cates

Consulting Picture Editors
Mimi Murphy (Rome),
Tala Skari (Paris)

Editorial Director
Stephen Koepp

Editorial Operations Director
Michael Q. Bullerdick

EDITORIAL OPERATIONS

Richard K. Prue (Director), Brian
Fellows (Manager), Richard Shaffer
(Production), Keith Aurelio,
Charlotte Coco, Tracey Eure, Kevin
Hart, Mert Kerimoglu, Rosalie
Khan, Patricia Koh, Marco Lau,
Brian Mai, Po Fung Ng, Rudi Papiri,
Robert Pizaro, Barry Pribula, Clara
Renauro, Katy Saunders, Hia Tan,
Vaune Trachtman

TIME HOME ENTERTAINMENT

President Jim Childs

**Vice President, Business Development &
Strategy** Steven Sandonato

**Executive Director, Marketing
Services** Carol Pittard

**Executive Director, Retail &
Special Sales** Tom Mifsud

Executive Publishing Director
Joy Butts

**Director, Bookazine Development
& Marketing** Laura Adam

Finance Director
Glenn Buonocore

Associate Publishing Director
Megan Pearlman

Assistant General Counsel
Helen Wan

Assistant Director, Special Sales
Ilene Schreider

Book Production Manager
Suzanne Janso

Design & Prepress Manager
Anne-Michelle Gallero

Brand Manager Roshni Patel

Associate Prepress Manager
Alex Voznesenskiy

Assistant Brand Manager
Stephanie Braga

Special thanks: Christine Austin,
Katherine Barnet, Jeremy
Biloon, Susan Chodakiewicz,
Rose Cirrincione, Lauren Hall
Clark, Jacqueline Fitzgerald,
Christine Font, Jenna Goldberg,
Hillary Hirsch, David Kahn,
Amy Mangus, Robert Marasco,
Kimberly Marshall, Amy Migliaccio,
Nina Mistry, Dave Rozzelle,
Ricardo Santiago, Adriana Tierno,
Vanessa Wu

We welcome your comments and
suggestions about LIFE Books.
Please write to us at:
LIFE Books
Attention: Book Editors
PO Box 11016
Des Moines, IA 50336-1016

If you would like to order any of
our hardcover Collector's Edition
books, please call us at
1-800-327-6388 (Monday through
Friday, 7 a.m.–8 p.m., or Saturday,
7 a.m.–6 p.m., Central Time).

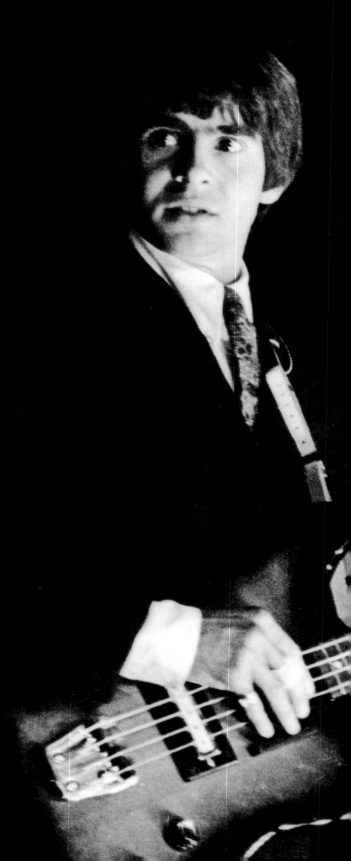

Page 1: Andy Griffith, *Everett*

Pages 2–3: Maurice Sendak's
Where the Wild Things Are,
Philip Gould/Corbis

These pages: Davy Jones, *J. Barry
Peake/Rex USA/Everett*

Farewell

REMEMBERING THE FRIENDS
WE LOST IN 2012

INTRODUCTION

Their Lives, Our Times

It is always hard to say good-bye. But at year's end as we look back at these lives, we find it is also time to celebrate—celebrate the good times, the memories, the accomplishments, the courage, the talent, the spirit. Most of the people on these pages were remarkable individuals who made our world a better place. Some few remain controversial after death, their legacy debated, but they are greatly overwhelmed by the strivers and achievers who did well by doing good. When these folks passed our way, we might not have noticed all that they were bringing to our lives. Now, in retrospect, we can fully appreciate their contributions, and apprehend how all lives matter greatly, and all walks of life are part of the mosaic.

As we assembled this book, themes developed. It is perhaps unsurprising that many members of the so-called Greatest Generation are coming to the ends of their lives. We really get a picture of how everyone in America was contributing in the 1940s when we realize that, for instance, among those who served in the armed forces during World War II were future presidential candidates and environmental crusaders, avant-garde publishers and art gallery owners, writers and songwriters and Oscar-winning actors, pro ballplayers and pro bowlers. They were being cheered back in the day by USO shows featuring the McGuire Sisters (Dorothy died this year), just as, later, soldiers in Vietnam would howl at the wisecracks of Phyllis Diller when she toured with Bob Hope's troupe.

The last surviving veteran of World War I died this year, as did several who served in Korea. Ambassador Chris Stevens was killed in Libya. The march of time is ever-present here; history unfolds. Courageous pioneers—the first woman in space, the first man on the moon—are remembered, as are a home cook who opened a restaurant in Harlem and an M.I.T. grad who invented Electric Football.

Who to do the remembering? In several cases, LIFE knew these people well: They had been in our pages or even on our cover. In other instances, we thought it would be edifying, fun or inspiring to hear from their friends, admirers or colleagues, and there are appreciations herein from Plácido Domingo, Martin Scorsese, Katie Couric, Jeff Kinney, Erica Jong, Ron Howard, Jim Lovell, Senator Al Franken, Micky Dolenz, Larry David, Joan Collins and others—including, on our final page, Big Bird.

It was not a sad exercise at all to review the photography of our subjects, and we did so with an eye for portraiture that showed them at the height of their powers and charisma. We thought hard about how to properly say "farewell," and to encourage the celebration. Our effort begins now. Please join us in tribute.

WE KNEW THEM WHEN Opposite, top row, left to right: Celeste Holm; integration in the South, an issue in which Nicholas Katzenbach was heavily involved; the McGuire Sisters, including Dorothy (right). Middle row: World War I, the last living veteran of which, Florence Green, died this year; Neil Armstrong's footprints on the moon; the Muppets, who lost the man behind Count von Count in 2012. Bottom row: Three earlier LIFE books from this year—on Whitney Houston, Dick Clark and, again, Neil Armstrong.

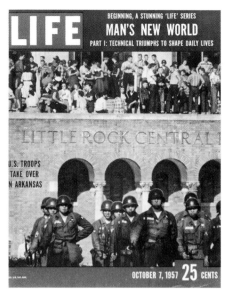

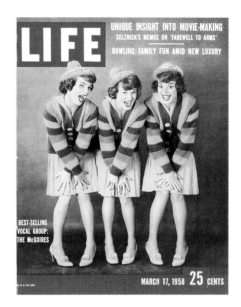

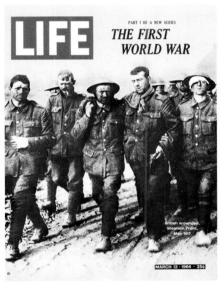

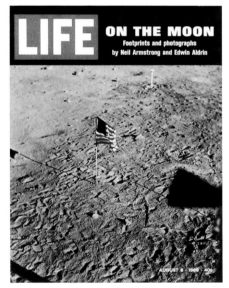

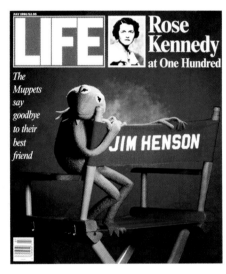

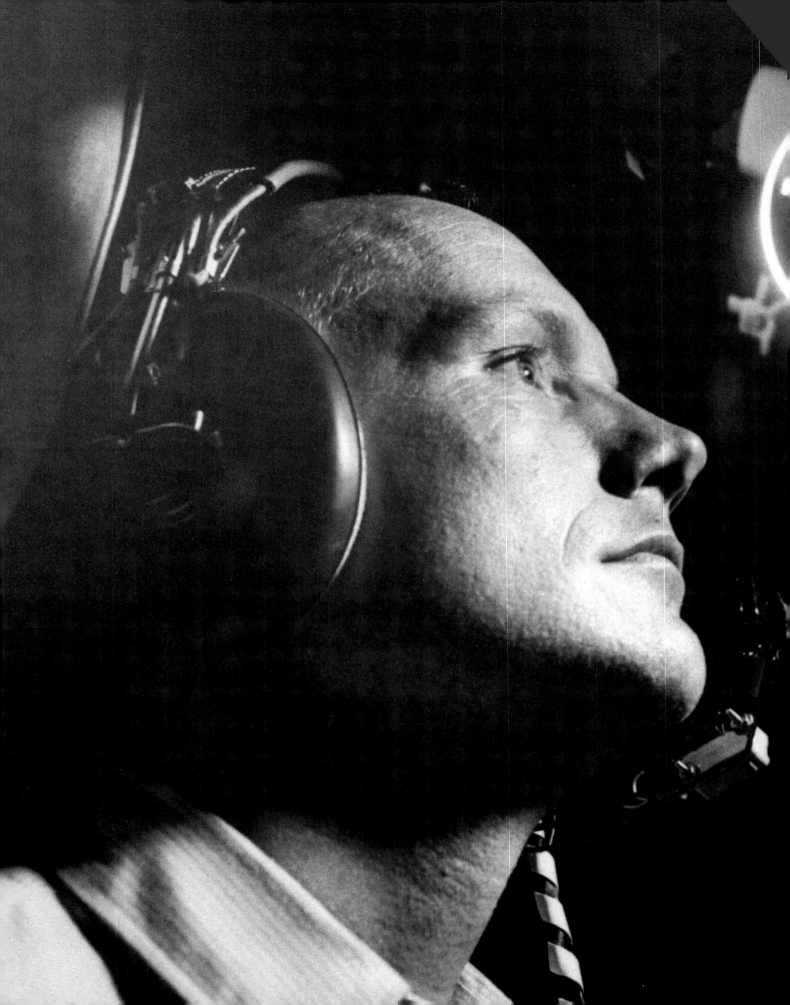

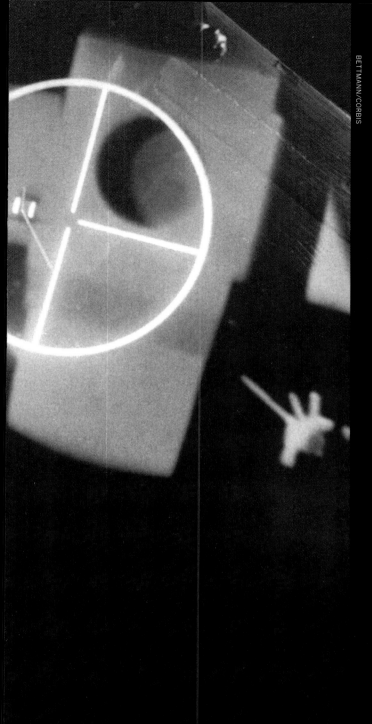

W hen the first man to step foot on the moon died in late August at age 82, LIFE, which had been so invested in the space race of the 1960s, went back to Armstrong's Apollo program mate Jim Lovell, who had been traveling with Armstrong in recent years on morale-boosting visits to American troops, and asked for an assessment of the man. Lovell, in accord with the person Armstrong had always been, was succinct and very much to the point: "It would be difficult to identify another American who achieved as much in his lifetime as Neil Armstrong, or one who ascended to the heights of global fame and recognition that resulted from his remarkable successes. In spite of it all, he remained a humble man and used his fame not for personal gain but to contribute to the legacy of America in the world." Indeed. Born in rural Ohio in 1930, Armstrong was a smart and dutiful boy—an Eagle Scout—who grew obsessed with flight and earned his pilot's license on his 16th birthday. He was nearly killed flying dozens of missions as a Navy aviator in the Korean War, then had equally close calls as a storied test pilot in the California desert. He decided to try out for NASA's astronaut corps, and as with everything else, he succeeded beyond measure. He took life seriously, and in 1969 he took seriously the role that had, by dint of hard work, uncommon skill and a measure of good fortune, fallen to him: "That's one small step for a man, one giant leap for mankind." After his return from the moon, he played his part in the requisite round of parades, worked for NASA in Washington for a short time, then retreated to Ohio, teaching aeronautics at the University of Cincinnati, remaining in his retirement the humble man of whom Lovell speaks. When he died, many looked at his life's story and said: We would all do well to be a little more like Neil Armstrong.

Neil Armstrong

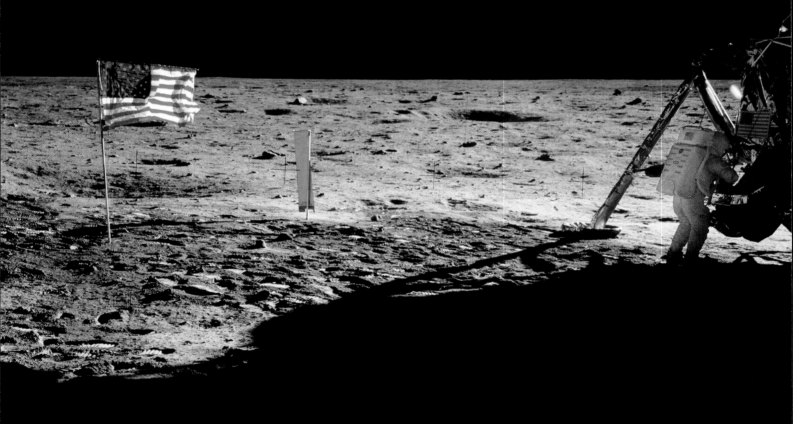

EVERYONE REMEMBERS the famous shots of an astronaut on the lunar surface—facing the camera or saluting the flag. Those pictures were taken by Armstrong of his *Apollo 11* colleague Buzz Aldrin, the second man on the moon (Armstrong can sometimes be seen reflected in Aldrin's visor). There are two good pictures of Armstrong himself on the historic day: one taken by a remote camera attached to the lunar module, and this one taken by Aldrin of the commander at work near that module, after the two of them had raised the famous flag (which is held horizontal by a metal rod, since there is no breeze up there to cause it to "flutter" movingly).

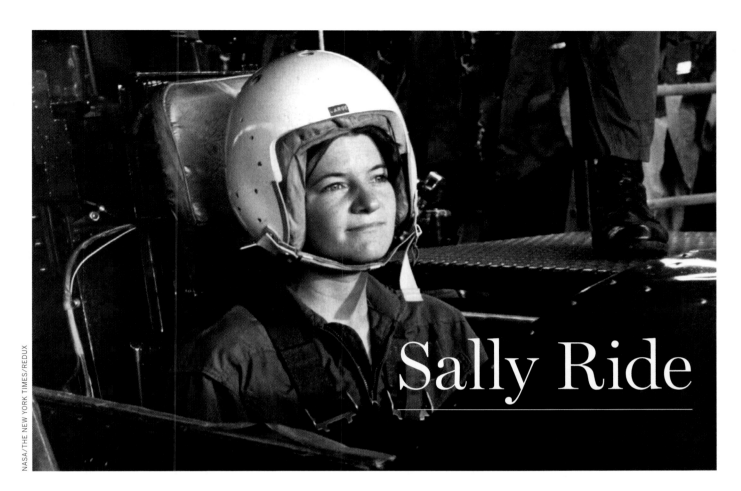

Sally Ride

Only weeks before the first man on the moon died, so did the first American woman in space when Sally Kristen Ride died in San Diego on July 23 at age 61. As is implied by this picture (preparing for a simulated ejection in 1978), the physicist Ride and other pioneering female astronauts were not passengers, they had as much of the right stuff as any flyboy—even if they were not always treated as equals of the men. Dr. Kathryn D. Sullivan, a geologist who herself was a member of three shuttle missions and in 1984 became the first American woman to walk in space, recalled for LIFE her late friend and colleague:

"My fondest memories of Sally are those times we shared laughs about the amusing reactions we encountered as the first women to join the astronaut ranks. Early on, it seemed nobody could tell the six of us apart. Someone would stop one of us on the space center campus and launch into technical details about a completely unfamiliar topic. They would be flummoxed when we interrupted with, 'Ah, you want to be talking to So-and-So. I'll tell her to call you.' Sally and I decided to test this interchangeability once by swapping identities in the receiving line at a large civic gathering. While the hostess was telling 'Kathy Sullivan' that she recognized her from her picture, the host was telling 'Sally' how he'd love to step out onto his tennis court for a match. There are several dozen people out there somewhere with Sally's autograph in my handwriting.

"To that mischievous sense of humor add curiosity, a keen intellect and an intense competitive drive—there you have Sally Ride in a nutshell. She did not seek the celebrity that came with being the first of us to fly. When it found her, she put it to use wisely and well in service of exploration and education, using her iconic status to inspire countless others to reach for the stars." Ride and her longtime life partner, Tam O'Shaughnessy, co-wrote six children's books about science. There is no telling how many little girls are shooting for the stars because of her.

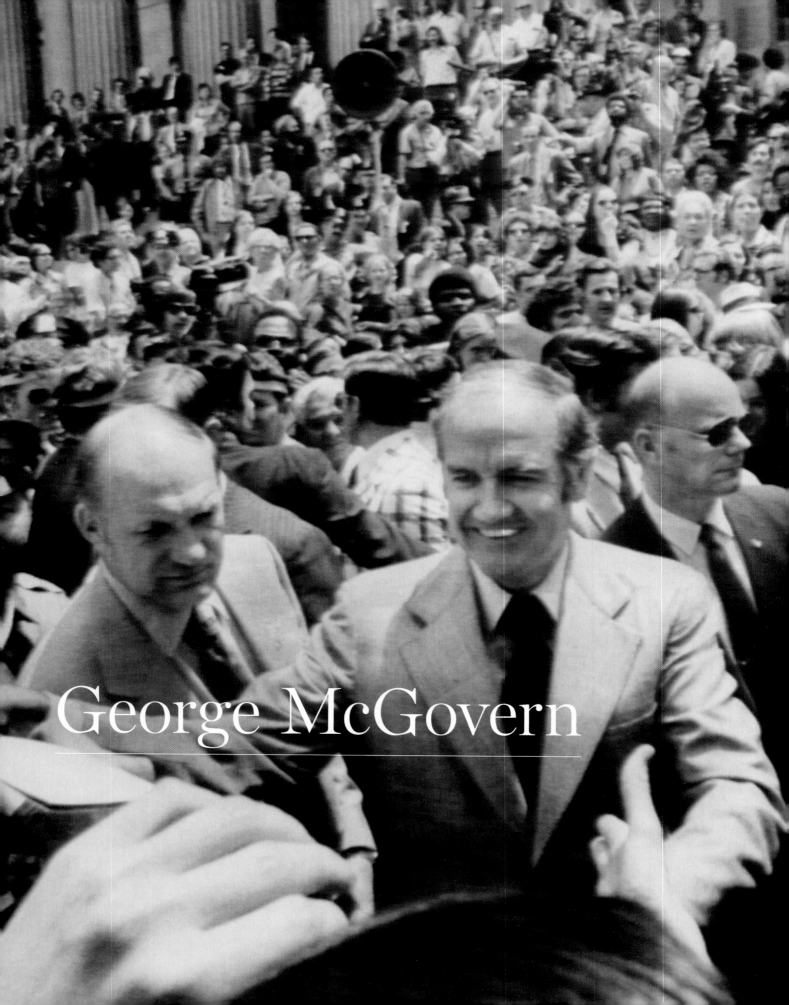

George McGovern

When this statesman, a three-term U.S. senator from South Dakota, died in late October at age 90, many commentators rushed to insist that his lopsided loss to Richard Nixon in the 1972 presidential campaign should not constitute his legacy. But for a moment, let's look at that "losing" campaign and what it has meant since. McGovern brought many volunteers and officials into the Democratic Party who remain shapers of its direction today; Bill Clinton, for instance, was his Texas coordinator before becoming governor of Arkansas. McGovern reintroduced a certain brand of prairie populism after it had been derided as an archaic premise. In a truly progressive sense, he proposed that not only should women be considered for all future vice presidential candidacies, but that he would put the first woman on the Supreme Court; today, there are three women sitting on the highest bench. That 1972 campaign was not simply about McGovern's staunch opposition to the Vietnam War, although it came to be seen as such at the time and has remained so in the popular mind-set.

It should be added: If anyone had the right to categorically oppose that war, it was George S. McGovern. This falls under the assumption that those who best understand when battle must be waged are those who have seen battle. The son of a Methodist minister (who happened to be a political conservative), McGovern flew a B-24 in World War II and, during 35 missions against Nazi targets in Europe, performed heroically, at one point guiding his wounded plane to safety by ordering that parachutes be tied to girders just inside the rear hatches, then having the chutes deployed upon landing. He won the Distinguished Flying Cross.

Back home, he eventually eschewed the ministry for a life in public service, while remaining interested in, and indeed dedicated to, "the nature and destiny of man." He was concerned with "the adequacy of our contemporary value system and the capacity of our institutions to nurture those values." Four decades after the 1972 campaign, such a concern remains—or should—a central part of our public discourse.

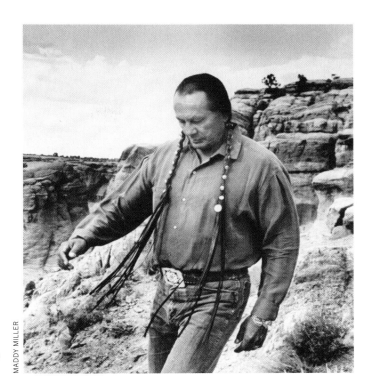

MADDY MILLER

Russell Means

One year after George McGovern's 1972 presidential run, fellow South Dakotan Russell Means, an Oglala Sioux, gained international fame—some would say notoriety—when he helped lead the 71-day armed occupation of Wounded Knee, a trading hamlet on the Pine Ridge Reservation. This was the site of an 1890 massacre of more than 200 Sioux, including women and children, by the U.S. 7th Cavalry. Means, who became a leader of the American Indian Movement, said such protests as Wounded Knee were about justice for the native people: that the Indian had been ignored in the civil rights debates and advances of the postwar years. Some critics who acknowledged Means's intelligence, passion and charisma, and who were not arguing with many of his claims or some of his goals, said that he, as an eloquent spokesman for his people, could have accomplished more had he not resorted to violence. Means said he always did what was necessary or justified, but in recent years he tried to shape his legacy: "I don't want to be remembered as an activist. I want to be remembered as an American Indian patriot." Means died of cancer at age 72 at his home on the Pine Ridge Reservation.

Mike Wallace

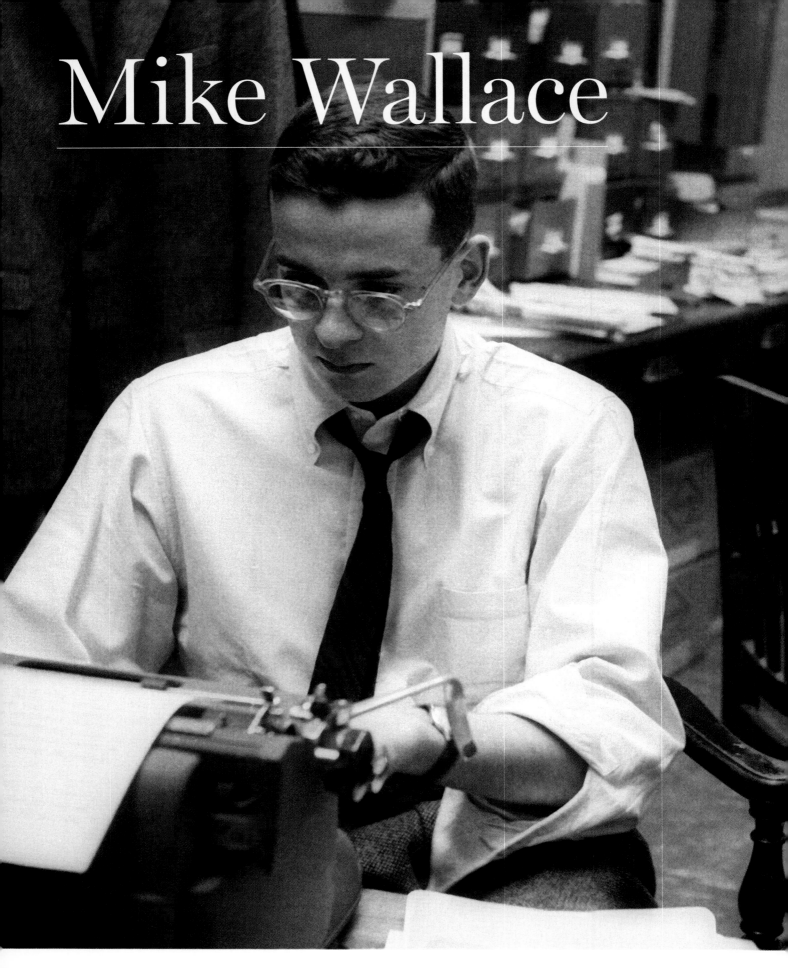

I n April the legendary television journalist died in Connecticut at age 93, and many friends, family members and associates at CBS mourned. There were perhaps others who, uncharitably, did not—these being the subjects of Wallace's hidden cameras and "gotcha" moments. Wallace himself never used the phrase, of course. That wouldn't have been professional. Also: It would have been superfluous.

"Irreverent, irascible, competitive beyond belief," was the way Morley Safer, who went way back at *60 Minutes* with Wallace, remembered his former colleague, who was also—much of the time—his friend. Safer said Wallace would not shrink from stealing a hot story from another correspondent, and that, "There were a couple of years there in which we didn't talk to each other." He attributed some of Wallace's behavior at the office to insecurity, saying that he always seemed "unsure of himself . . . Mike always felt that he had not paid his dues as a journalist, and I think it's one of the things that made him such a tough guy." Safer suspected that Wallace, who was diagnosed in middle age with chronic depression, harbored "shame" over his show-business roots.

Maybe he did, for those roots had little to do with the hard-hitting newshound persona he later built for himself. A Massachusetts native, the son of Russian Jewish immigrants started out on TV on a quiz show in 1939, and after serving as a naval communications officer in World War II, worked as an announcer for radio shows (including *The Green Hornet*), a sportscaster for wrestling matches and host of several game shows. Such as John Cameron Swayze and Walter Cronkite segued back and forth between news and entertainment in this era, and Wallace, too, saw himself powerfully drawn to real-world events. By the time the photograph at left was taken in a New York City newsroom, Wallace was vigorously reinventing himself, and when *60 Minutes* was ready to launch in 1968, the American audience was ready for tough-guy Mike Wallace.

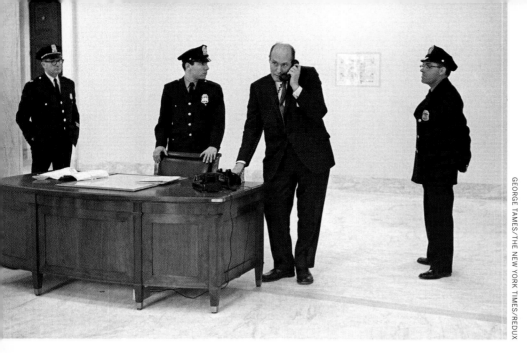

George Tames/The New York Times/Redux

Nicholas Katzenbach

The 1960s was of course a decade rife with critical, society-changing problems and decisions, and Lyndon Baines Johnson, one of the Presidents to lean on Katzenbach in this period, said of him: "Few men have been so deeply involved in the critical issues of our time." Those included the Cold War, civil rights battles, investigations into the assassination of John F. Kennedy, the turmoil of the Vietnam War and myriad other, though never lesser, situations. A smart, imposing man (a Rhodes Scholar, 6 foot 2 inches tall and a former hockey goalie)—one of Kennedy's best and brightest (also, biggest)—he was something of an oxymoron: a no-nonsense idealist. When Johnson assumed the presidency after Kennedy was killed, and then decided that civil rights legislation was to be a principal concern of his administration, Katzenbach, who is seen here in 1965 and who died in May at age 90 in New Jersey, took the lead as attorney general. Among the finest of his many brilliant career moments (he had earlier counseled JFK during the Cuban Missile Crisis) occurred on June 11, 1963. It was a brutally hot day in Tuscaloosa, Alabama, and Governor George C. Wallace was holding forth outside the University of Alabama: "Segregation now, segregation tomorrow, segregation forever!" Wallace vowed that two black students on the premises would not be allowed to enroll. Katzenbach, who was on the scene with federal marshals, was diplomatic and resolute, which, as we are painfully aware, is a combination rare in politics today. He asked the two students, Vivian Malone and James Hood, to stay in the car. Then he approached Wallace, saying: "I'm not interested in this show." The rest is history, history in which Nicholas deBelleville Katzenbach not only participated but that he helped forge.

Chris Stevens

On September 11, precisely 11 years after America was attacked on its home soil by Muslim radicals, the American consulate in Benghazi, Libya, was besieged and four members of the U.S. diplomatic corps were killed, including Ambassador J. Christopher Stevens, 52. The ignorance of the assailants, and the cruel irony of the situation, became immediately clear: Stevens had been uncommonly, selflessly dedicated to improvement in the region, and had in fact supported the rebel faction during the Arab Spring overthrow of the dictatorial Muammar Gadhafi. "He risked his own life to lend the Libyan people a helping hand to build the foundation for a new, free nation," said Secretary of State Hillary Clinton. "Chris was committed to advancing America's values and interests, even when that meant putting himself in danger."

Bettmann/Corbis

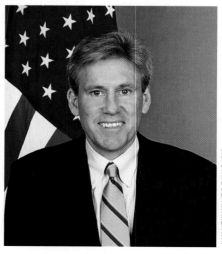

U.S. State Department/AP

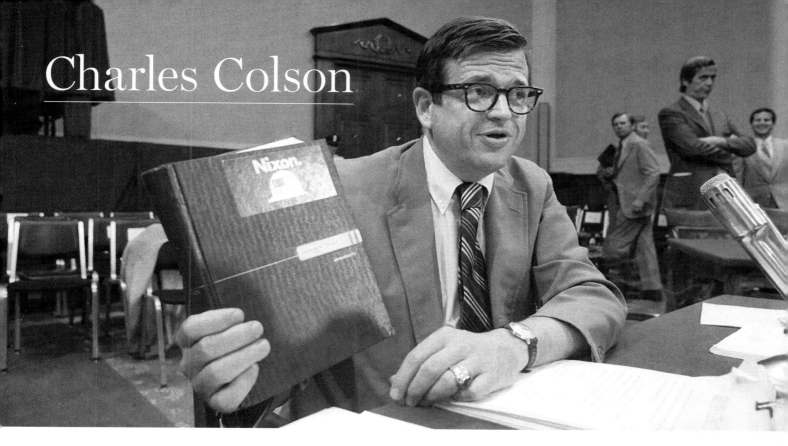

Charles Colson

Famous primarily for his role in the Watergate cover-up and secondarily for his later-in-life calling as a Christian evangelist, Boston native Charles Wendell Colson died in March at age 80 in Virginia.

His fellow Watergate conspirator John Dean remembered him to LIFE: "Although Chuck Colson and I agreed about little, even when colleagues at the Nixon White House, we had a long, and for a brief time, close friendship based on mutual respect. After we pled guilty to criminal behavior at the Nixon White House, we were together for a brief period in the custody of the U.S. marshals at a 'safe house' at Fort Holabird, Maryland. There we set aside our differences. Chuck admitted he had tried to destroy me as part of his effort to defend Nixon's presidency, and he apologized. This prompted a number of protracted conversations about Watergate that stretched over many years, our last in July 2006.

"From the outset, I knew Chuck was never going to fully own his role in the abuses of presidential power. While he conceded moral responsibility for his actions, he was unwilling to acknowledge specific conduct, like that the Watergate special prosecutors had little doubt they could prove criminal beyond a reasonable doubt. Because he departed the White House before the Nixon presidency collapsed, Chuck left with his papers (which belonged to Nixon) and no doubt a few secrets, for he once mentioned to me that it took years to prune them before giving them to Wheaton College.

"When he published *Born Again* in 1974, his first of many books about his religious beliefs, I tweaked him about his 'redeemed life' absent a complete confession. *Born Again*, with its gloss on history, was as close as he could come to publicly admitting any specific wrongdoing. This is not to say history has lost the information of his important role at the Nixon White House. He (as with many other key players) left behind countless conversations secretly recorded by Richard Nixon, which I am currently transcribing as part of my effort to figure out who knew and did what, and when.

"I never doubted Chuck's life-changing embrace of evangelical Christianity. After Holabird, and when serving at a small federal penitentiary at Maxwell Air Force Base, Chuck found his life's calling: a prison ministry which profited greatly from his considerable energy and ability. Chuck's Prison Fellowship fulfilled his life, surely bringing him true peace and happiness, not to mention a wonderful legacy."

Rodney King

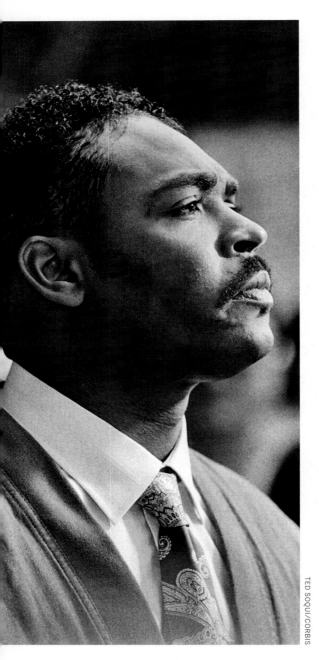

TED SOQUI/CORBIS

Here, on May 1, 1992, is when King became a seminal figure in modern American history. He had been beaten by Los Angeles police after a high-speed car chase. Though the incident had been caught on videotape, the trial of the police officers ended in acquittal, sparking six days of riots in L.A. and elsewhere that left hundreds of businesses destroyed in fires and nearly five dozen people killed. Now, in the midst of the turmoil, Rodney King went before the cameras to ask, "Can we all get along?" That equanimity from a victim of societal—official—wrongdoing changed the discussion. "It was his beating that made America focus on the presence of profiling and police misconduct," the Reverend Al Sharpton reflected after King was found dead in his Rialto, California, swimming pool at age 47. "Rodney King was a symbol of civil rights and he represented the anti–police-brutality and anti–racial-profiling movement of our time." Sharpton's was not too large a claim, as Bernard Parks, L.A.'s police chief from 1997 to 2002 and today a city councilman, admitted: "Although his beating will forever be thought of as one of the ugliest moments in the history of the city of Los Angeles and its police department, the victimization of Mr. King and the circumstances that followed created an atmosphere that allowed LAPD and the city to make historic disciplinary and community-based reforms that have made for a better police department and a better city as a whole." He added, personally, "I am saddened by the death of Rodney King." There were sad episodes in the life of King following his famous run-in with the law in '91: other occasional troubles with police, incidents of substance abuse, ups and downs with employment. He was engaged to be married when he died. King's legacy will always be that humanist speech, and the reforms it engendered.

Thelma Glass

When she died in July she was 96, a retired professor of geography at Alabama State University. Back in 1955, she was working at the Women's Political Council (WPC) when the organization got word that Rosa Parks had been arrested in Montgomery for refusing to give up her bus seat to a white man. The WPC realized that three fourths of the bus riders in the city were black and called on African Americans (as they were not yet generally called) to boycott the buses in order to put pressure on authorities to change their ways. "We didn't have time to sit still and be scared," said Glass.

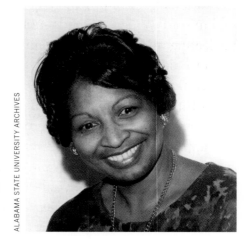

ALABAMA STATE UNIVERSITY ARCHIVES

James Q. Wilson

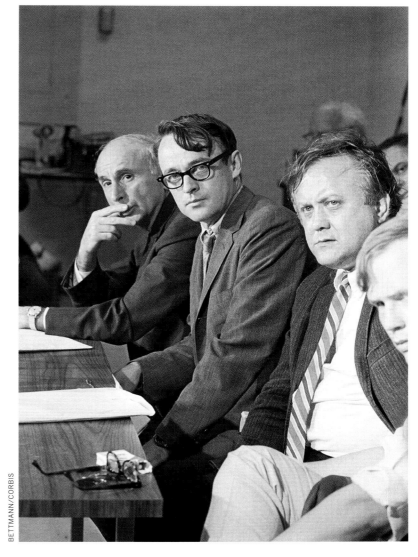

The political scientist who died at age 80 this year was the coauthor of a theory in 1982 that has become vastly influential in modern-day law enforcement, as William J. Bratton, former police chief in Boston, New York City and Los Angeles, explained in a tribute to LIFE: "James Q. Wilson [second from left] was without doubt one of America's greatest thinkers about the issues of police, crime, disorder and social behavior. His extensive research and body of work during his career at UCLA, Harvard, Pepperdine, and his association with the influential Police Foundation and Manhattan Institute, helped to shape the thinking and ultimate effectiveness of many public sector and police leaders.

"I began my 30-year relationship with Jim Wilson and his colleague George Kelling when they coauthored the *Atlantic* magazine article titled 'Broken Windows: The Police and Neighborhood Safety.' That watershed article for the first time correctly advanced the idea that disorder (minor forms of crime) was significantly linked to fear of crime and if left unchecked would breed conditions in which more serious crimes would flourish and grow. It resonated with me strongly because these had been my real-life experiences in policing the streets of Boston in the late 1970s. I would go to community meetings in some of the highest crime neighborhoods with all kinds of data about serious crime only to encounter, without fail, community members who wanted to discuss the multitude of minor crimes that were creating not only fear but were destroying their neighborhoods. We had missed the link between serious crime and disorder and had prioritized serious crime fighting while neglecting minor crimes. Not until the creation of community policing in the late 1980s and its emphasis on both did we begin to reverse the crime epidemic.

"Unlike so many of his fellow researchers, Wilson was able to take complete ideas and theories and break them down to their simplest form. Like 'Broken Windows,' these didn't just resonate with his fellow researchers but more importantly with practitioners like me who could understand and appreciate them and apply them in the real world, something I was able to do with significant success in Boston, New York and Los Angeles, and many of my colleagues were able to do across America in the 1990s. 'Broken Windows' policing was and continues to be an essential strategy in any successful attack on crime, disorder and fear in any American city. It's just one small piece of the legacy of James Q. Wilson, my friend and mentor, that has benefited countless millions in our society."

BETTMANN/CORBIS

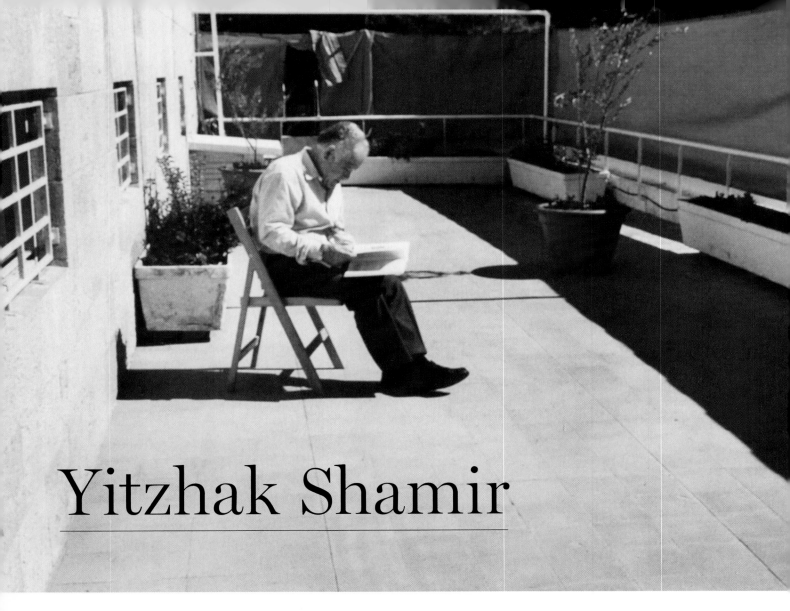

Yitzhak Shamir

K arl Vick, the Jerusalem Bureau Chief for *Time* magazine, put it into perspective for LIFE's readers: "The arc of Yitzhak Shamir's life describes the history of modern Israel. Both were built on the ashes of the Holocaust, which claimed every member of the family he left in Poland; his father was stoned to death by neighbors. Born Icchak Jazernicki, he chose a Hebrew name that translates as 'thorn,' and lived up to it. In pre-independence Israel, Shamir was a leader in the Stern Gang, the most militant of the groups fighting the British troops then in charge. Sleeping in orange groves and donning disguises—often as a Hasidic rabbi—he gunned down police in the street and plotted the Cairo assassination of Britain's top Middle East diplomat.

"Dubbed a 'terrorist' by the liberal Labor party that controlled Israel in its first decades, Shamir spent more than a decade in the Mossad, entering politics as the country began its shift to the political right. He championed an expansive vision of 'Greater Israel,' arguing for borders extending from the Suez Canal to Iraq. Treaties with Egypt and Jordan prevented that, but as leader of the Likud party, Shamir was zealous in sending Jewish Israelis to populate settlements on the West Bank. Their presence snarled prospects for a future Palestinian state that Shamir preferred to prevent, usually by stalling. As a *Time* pundit put it at the time: 'Nobody does nothing better than Shamir.'

"When he died on June 30 at age 96, of Alzheimer's disease, the outlaw had served as prime minister longer than anyone except David Ben-Gurion, Israel's founding father."

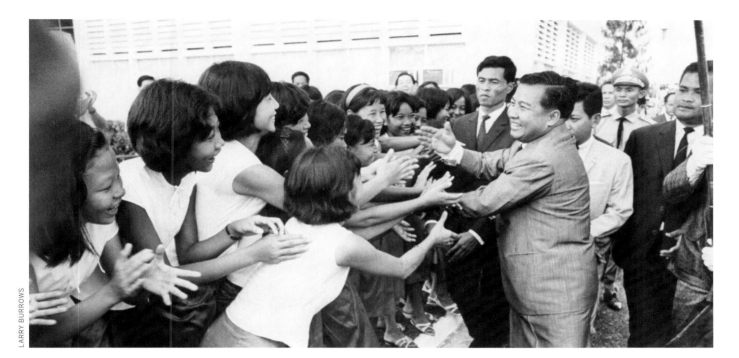

LARRY BURROWS

ROBERT A. CUMINS/CORBIS

Norodom Sihanouk

Known as the King-Father of Cambodia and by any number of other titles (it is said that in the past 70 years, no politician in the world has held so many different offices), Sihanouk, who ascended to the throne in 1941, abdicated twice, most recently in 2004, but was always esteemed by his people, even when he was briefly serving as a puppet ruler for the murderous Khmer Rouge in 1975. Sihanouk, who died at age 89 in Beijing, where he had been living, was publicly mourned back home by hundreds of thousands of his countrymen.

GENE J. PUSKAR/AP

Arlen Specter

He was always on the outs with some in his party. From 1951 to 1965, he was a Pennsylvania Democrat, not liberal enough for many of his confreres. From '65 until 2009, he was what was called "a moderate Republican," serving in the U.S. Senate for 30 years, beginning in 1980. A last straw for the right wing was his support of President Obama's stimulus package, and in 2009, before the 2010 election cycle, he switched back to the Democrats but was beaten in the primary, thus ending his political career. Eighty-two years old, he had fought non-Hodgkins lymphoma off and on for seven years before succumbing in October.

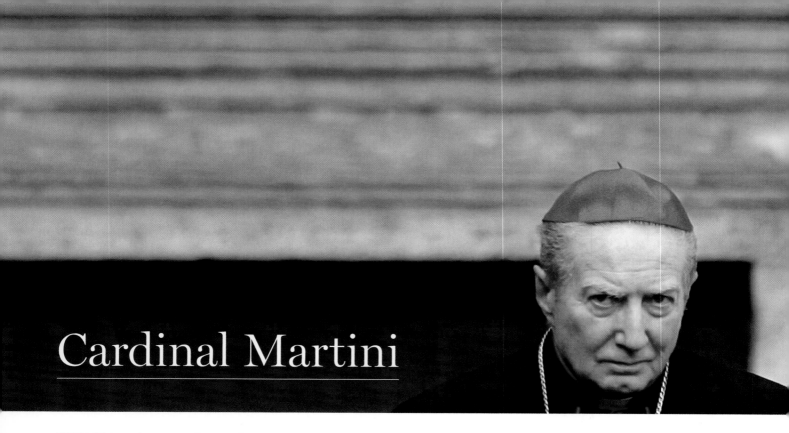

Cardinal Martini

The photographs on this page comment on Roman Catholicism in the 20th century—what was going on, and how the Church chose to present itself, sometimes drawing a cloak over the truth. Despite appearances, Cardinal Carlo Maria Martini, pictured above, should be seen as anything but sinister as he arrives at the Vatican conclave in 2005 to elect a successor to Pope John Paul II. He was, throughout his career, a great and good man, and would have been a worthy choice to sit upon Saint Peter's Throne. The Italian Jesuit, a former Archbishop of Milan considered too theologically liberal by some peers, was not elected, of course; Cardinal Joseph Ratzinger became Pope Benedict XVI. Cardinal Martini, who was 85 when he died in August, said in an interview posthumously published in an Italian newspaper, "Our culture has aged, our churches are big and empty and the Church bureaucracy rises up . . . The Church must admit its mistakes and begin a radical change, starting from the pope and the bishops. The pedophilia scandals oblige us to take a journey of transformation." Which brings us to the man pictured below.

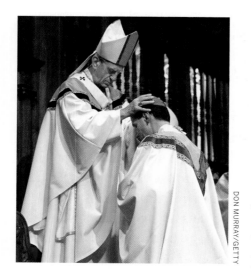

DON MURRAY/GETTY

Cardinal Bevilacqua

In 2002, the Archbishop of Philadelphia, Cardinal Anthony Bevilacqua, is seen laying hands on the Reverend Michael F. Burbidge during a bishopric ordination ceremony in the City of Brotherly Love's Cathedral Basilica of Saints Peter and Paul. Cardinal Bevilacqua retired the year after this photograph was made; he subsequently was called to testify no fewer than 10 times before grand juries investigating whether the Church had protected priests accused in Pennsylvania of molesting children. A final report concluded that Bevilacqua had been complicit in putting thousands of Catholic youths in harm's way. The cardinal died in January at age 88.

William Hamilton

"God is dead," wrote Nietzsche in the 19th century. He went on from there, but his thesis remained dormant—if not altogether dead—in the United States, at least, for many decades. Then arrived the all-questioning 1960s, and on April 8, 1966, *Time* magazine asked in a famous cover story, "Is God Dead?" The death-of-God theological movement—theothanatology, as it is called—had among its most prominent proponents two who died this past year, Gabriel Vahanian, whose 1961 book, *The Death of God,* was a seminal tract, and, seen here looking like an impassioned evangelist during a 1966 "Teach-in on God" at the University of Colorado, William Hamilton. Vahanian held that secular humanism in the modern world had lost touch with God, and he and Hamilton, a Christian theologian at Colgate-Rochester Divinity School in New York, were agreed—and aggrieved—that contemporary society seemed unconcerned with concepts of spirituality or transcendence. Hamilton (along with Vahanian) was popularly perceived as a God-hating atheist, but in fact he held that Jesus could be looked to as exemplary of a spiritual human being who is inspired by, in fact fully informed by, love.

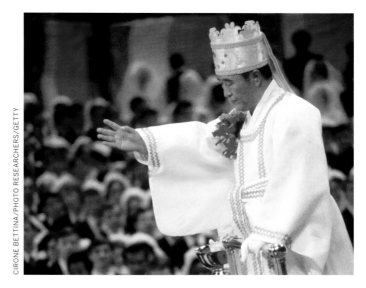

Rev. Sun Myung Moon

His goal was boldly stated: He had been chosen to fulfill Jesus's unmet task of saving the human race. This could only be attained, said Moon, by the propagation of sinless children. These ideas, on top of his fervid anti-communism and earthly charges that he was a spy for South Korea, landed him in a North Korean prison in the 1940s. But his Unification Church bloomed, then boomed in Korea, spreading to Japan. In the early 1970s he began proselytizing in the United States. Pairing off his disciples (sometimes with the help of questionnaires), he married many thousands of "Moonies" in mass ceremonies, like this one in Madison Square Garden in New York City; the men wore identical blue suits, while their brides were resplendent in satin gowns. Meanwhile, Moon espoused far-right politics and in 1982 founded the conservative newspaper *The Washington Times.* His relentless certitude and self-promotion led to an arranged coronation as "humanity's savior" at a Senate Office Building luncheon in 2004, a particularly embarrassing episode that surprised attending legislators. For all the Sturm und Drang surrounding the Moonies, the reverend's flock in the U.S. probably never numbered above the tens of thousands and was a fraction of that estimate when the Unification Church's leader died in September at age 92.

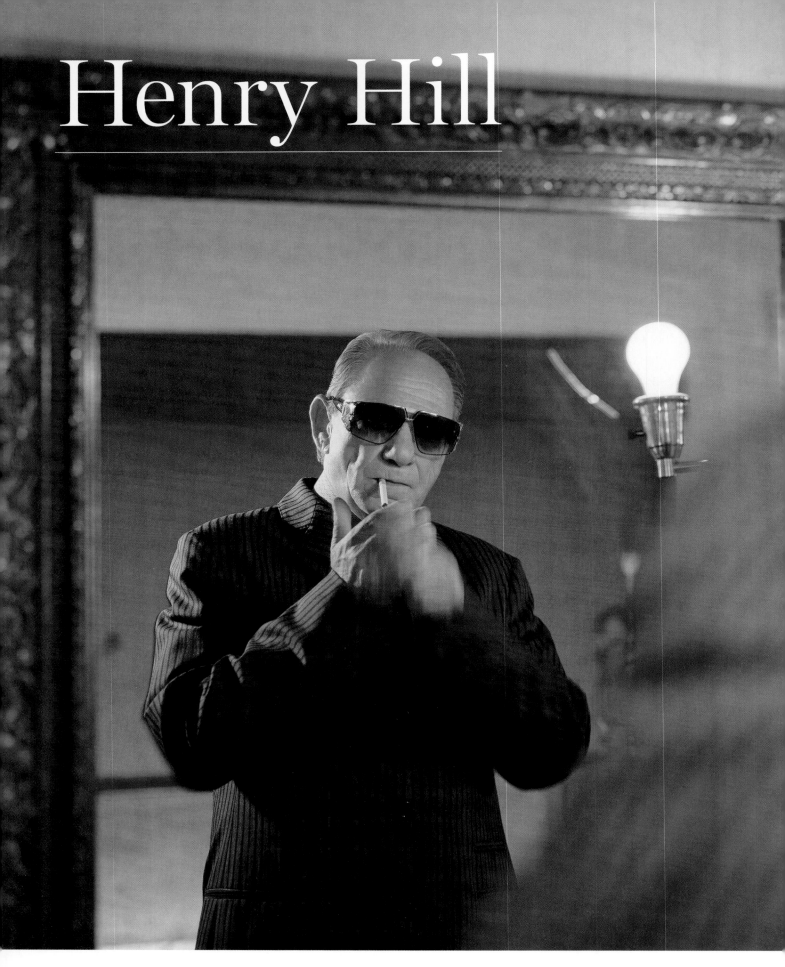

Henry Hill

He was anything but a good fellow, although he will be remembered (by those who choose to do so) as a *goodfella*. Which is to say: Hill, seen at left in 2002, was immortalized (in the best-seller and Hollywood way of immortalization) by Nicholas Pileggi's book *Wiseguy* and then Ray Liotta's scenery-chewing performance as a drug-addled gangster in Martin Scorsese's classic 1990 film *Goodfellas*. The Irish-Italian Hill was born into poverty in New York City in 1943 and as a teenager fell in with associates of the Lucchese crime family who associated right across the street. He chose criminality over high school, and after a stint in the Army in the early 1960s, he went all-in with the mob; his greatest hit was as one of the principal planners behind the notorious Lufthansa airport robbery in 1978. Hill never went straight, not even in prison; eventually he was facing such a bleak future that he snitched and was placed in the U.S. Marshals' witness protection program. In 1987 he was busted in Seattle on drug charges, and in the early 1990s was kicked out of the protection program. Apparently he had become inconsequential enough that the badfellas allowed him to continue to live, and after another drug bust and a long bout of alcoholism, Hill found stability of a sort as proprietor of a restaurant called Wiseguys in Connecticut and as a regular on the Howard Stern radio show.

Dr. Earl Rose

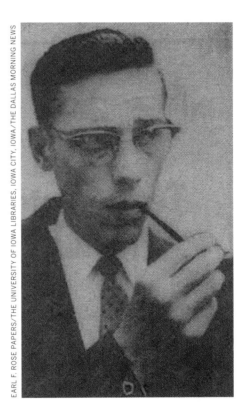

In November of 1963 he was the Dallas County medical examiner in Texas, and when President John F. Kennedy was assassinated, Rose, who died this spring in Iowa at age 85, was legally bound to perform an autopsy. But the President's widow and aides stepped in, insisting the body be flown to the East Coast forthwith. The autopsy was eventually executed at the National Naval Medical Center in Bethesda, Maryland, by pathologists who didn't even know that a tracheotomy had already been performed in Dallas. The rest has become part of the conspiratorial morass that has forever enshrouded the President's murder. It didn't have to be so, Dr. Cyril Wecht, the noted pathologist and longtime critic of the Warren Commission's investigation into the Kennedy assassination, told LIFE: "I deeply regret that the Feds illegally took the President's body out of Dallas rather than having a competent medical examiner like Dr. Earl Rose perform the autopsy. If Dr. Rose as medical examiner in Dallas had performed the autopsy on John F. Kennedy we would not be in the position we are in 49 years later. Even in each camp of opinion, there are disagreements about what actually happened. We do not even know where the bullet holes were located. It is incredible that two of the pathologists in Bethesda had never performed an autopsy on a bullet-wound fatality, yet performed the autopsy on the President of the United States. If the body had remained in Dallas, as was legally required, we might still be arguing about who Lee Harvey Oswald was, but we would know what the bullet holes looked like and exactly where they were located anatomically."

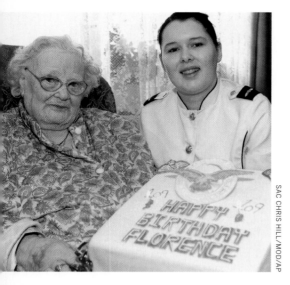

SAC CHRIS HILL/MOD/AP

Florence Green

Here she is at home in King's Lynn, Norfolk, England, on February 19, 2010, being presented a 109th birthday cake by Hannah Shaw on behalf of the Royal Air Force. A year later, upon turning 110, she was asked how that felt, and she replied, "It's not much different to being 109." Well said, Mrs. Green. Her life did finally come to an end this past year, and thus was taken from us the last veteran of World War I. A London native, Florence Patterson joined the Women's Royal Air Force in 1918 when she was just 17 years old, and served during the war as an officers' mess steward. She lived in King's Lynn for more than 90 years, 55 of them with her husband, Walter Green, a railway worker who died back in 1975 at age 82. History marches on, but there will be no more living testimony from veterans of the Great War.

Wesley Brown

On May 22, the first African American graduate of the United States Naval Academy in Maryland, a man who endured racial hazing at school and eventually rose to become a lieutenant commander in the Navy, died in Silver Spring, Maryland, at age 85. Former U.S. President and fellow Navy veteran Jimmy Carter remembered his schoolmate: "I went to the Naval Academy from Plains, Georgia, and my first personal experience with total racial integration took place when an African American student, Wesley Brown, joined the brigade. Although he was two classes behind me, we both ran cross-country during the year we were at the Academy together. My primary memory of him is that he always was judged on his performance—and he always crossed the finish line ahead of me. A few members of my senior class attempted to find ways to give him demerits so that he would be discharged, but Brown's good performance prevailed, and he became the first African American to graduate from the Naval Academy. I learned from Wesley Brown."

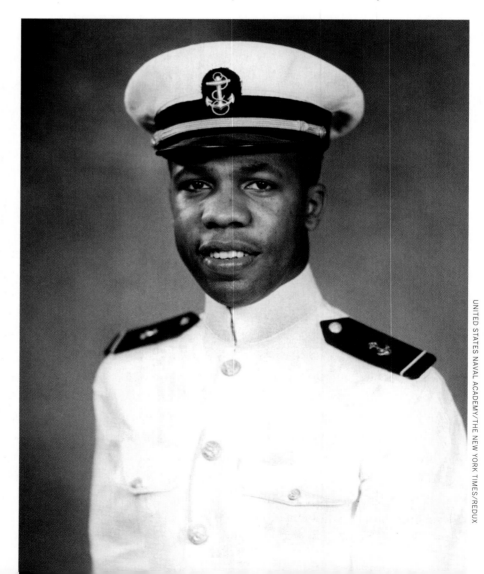

COURTESY GEORGE HICKMAN/AP

UNITED STATES NAVAL ACADEMY/THE NEW YORK TIMES/REDUX

George Hickman

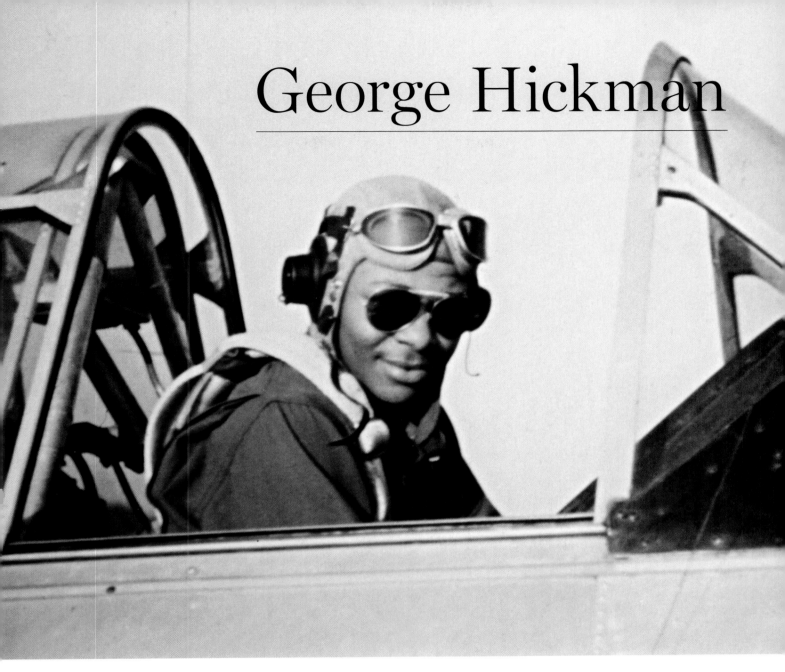

Born in St. Louis in 1924, George Hickman was captivated by the idea of flight as a young man. After graduation from Sumner High, he and other African American classmates enrolled at the Tuskegee Institute in Alabama, where they were trained as fighter pilots. The all-black 99th Squadron, the so-called Tuskegee Airmen, went on to valor over Europe during World War II, and their success was instrumental in leading to a desegregated U.S. military. Their contribution wasn't always recognized; Hickman remembered being spit at in the South even when in uniform. He eventually settled into a good life in Seattle's Montlake neighborhood, working in the engineering department at Boeing while helping his wife, Doris, raise their four children. In recent years Hickman traveled across the country to Washington, D.C., twice: in 2007, to receive the Congressional Gold Medal along with his fellow surviving Tuskegee Airmen, and in 2009 for the inauguration of Barack Obama. It amazed him, said his daughter Regina Melonson, "that he would live long enough to see an African American President in the White House." She continued: "My father loved life. He loved people. He ventured out and was courageous to do things that other people would maybe be afraid to do, especially because of all the racism and discrimination he experienced. He just never let it slow him down."

As a writer, he could charm; his prose was brilliant, humorous, eloquent and always alive. His string of historical novels, including *Burr* and *Lincoln* among several, were enlightening—even educational—while never being anything less than exciting and fun. His provocations like *Myra Breckinridge* were the very definition of the phrase *literary sensation*. His essays were trenchant, fact-based and passionate. His screenplays were the work of a pro, and his stage plays were memorable entertainments. They were also, like much that he created when putting pen to paper, of lasting quality; when Gore Vidal died at age 86 in Los Angeles's Hollywood Hills, his 1960 play, *The Best Man*, was being presented in a revival on Broadway with a new title reflecting the author's stature and fame: *Gore Vidal's The Best Man*.

As a person, Eugene Luther Gore Vidal Jr. was witty, erudite and handsome. He appeared regularly on Johnny Carson's *Tonight Show* and was even asked to serve as guest host. But he could also be difficult—intentionally so. "I'm exactly as I appear," he once said. "There is no warm, lovable person inside. Beneath my cold exterior, once you break the ice, you find cold water." His gargantuan self-assuredness—"There is not one human problem that could not be solved if people would simply do as I advise"—certainly contributed to losses when he twice ran for public office, and was part of the volatile mix that led to virulent, occasionally violent, feuds with such as Norman Mailer, Truman Capote and William F. Buckley Jr., feuds that sometimes were enacted on television or detailed in lawsuits. Calling Buckley a "crypto-Nazi" and comparing Mailer to Charles Manson were strategies bound for no good end.

Gore Vidal, who enjoyed a lifelong debate with his native land, was an American original—a combination of the classic man of letters and the modern multimedia celebrity. He was awarded a lifetime achievement citation by the National Book Awards and appeared as himself, in animated form, on *Family Guy*. More diverse claims to fame can scarcely be imagined.

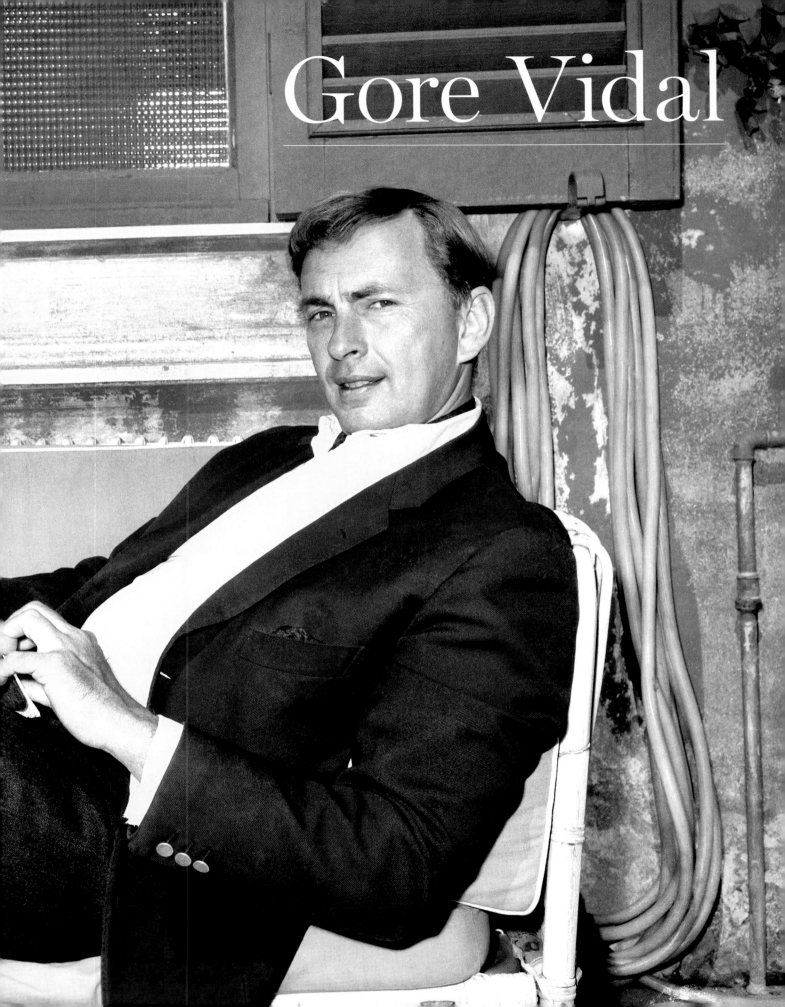

Gore Vidal

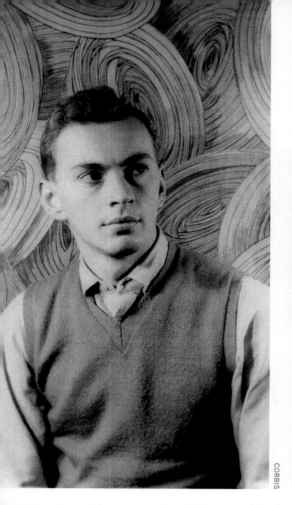

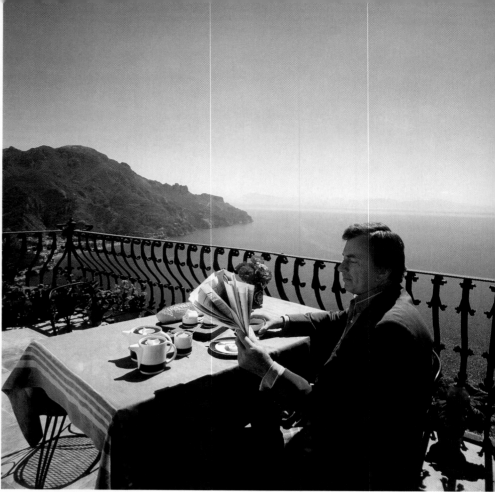

IN 2009, Vidal told *The Times* of London that the United States was "rotting away at a funereal pace," and in his many essays he delineated at far greater length and with more detail his quarrels with America. He chose to live elsewhere for much of his life, and the portrait on the previous pages as well as the color photographs on this page were made at his cliffside villa in Ravello, Italy; the picture at top left is of the artist as a younger man. In 2003, Vidal and his companion of more than a half-century, Howard Austen, relocated to Los Angeles to be closer to hospital services. Austen, who died that year, said to Vidal near the end, "Didn't it go by awfully fast?" Vidal wrote in his memoirs: "Of course it had. We had been too happy and the gods cannot bear the happiness of mortals."

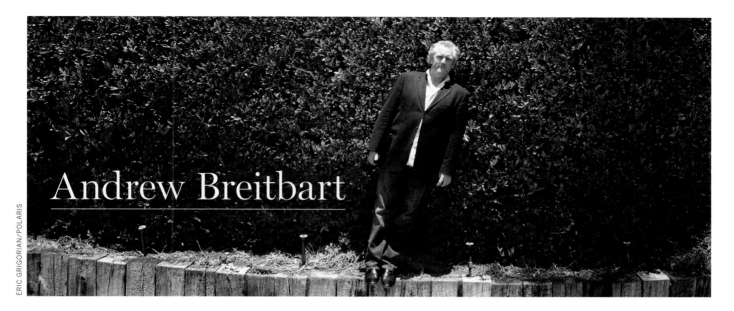

Andrew Breitbart

The conservative blogger and provocateur Breitbart, seen here playfully leaning left, was only 43 years old when he died in California of heart failure. His political soulmate, radio and Fox News commentator Monica Crowley, remembered him to LIFE: "Andrew Breitbart was a one-of-a-kind 21st-century happy warrior. He was brilliant, eclectic, and fearless as he pioneered the use of new media to bring America back to its foundational principles of limited government, fiscal responsibility and national integrity. He recognized that we are in multiple wars for our future—ideological, economic, political, cultural—which must be fought lest we lose the country to the malign forces of devastating statism. But he also recognized that those battles must be waged with a joyful confidence in the mission and with quintessentially American optimism. The nation lost a bright light when we lost Andrew. He was a true patriot, a loyal friend, and a good man. But in the vast army of those he inspired, he leaves a powerful and enduring legacy."

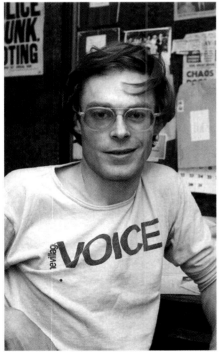

Alexander Cockburn

The leftist writer and editor Cockburn, seen here in 1977, was 71 when he died in Germany of cancer. His former colleague at *The Nation* Victor Navasky sent this tribute to LIFE: "His world-view, part Marxist, part anarcho-syndicalist, part libertarian and part anti-anything that smacked of liberal pieties, informed his Mencken-with-an-English-accent prose. His stints ranged from the *New Left Review, The Village Voice* (where he invented a new form of press criticism in his "Press Clips" column) and *The Nation* to *The Wall Street Journal* and other venues too diverse to mention. He had moved to the town of Petrolia, in California's Lost Coast region, where he cofounded the biweekly newsletter *CounterPunch* (which he described as 'muckraking with a radical attitude'). To the end he followed a rule of his *Daily Worker*–contributor father, Claud Cockburn: 'One should never believe anything until it's officially denied.' An equal opportunity offender, he specialized in attacking the powerful and the corrupt."

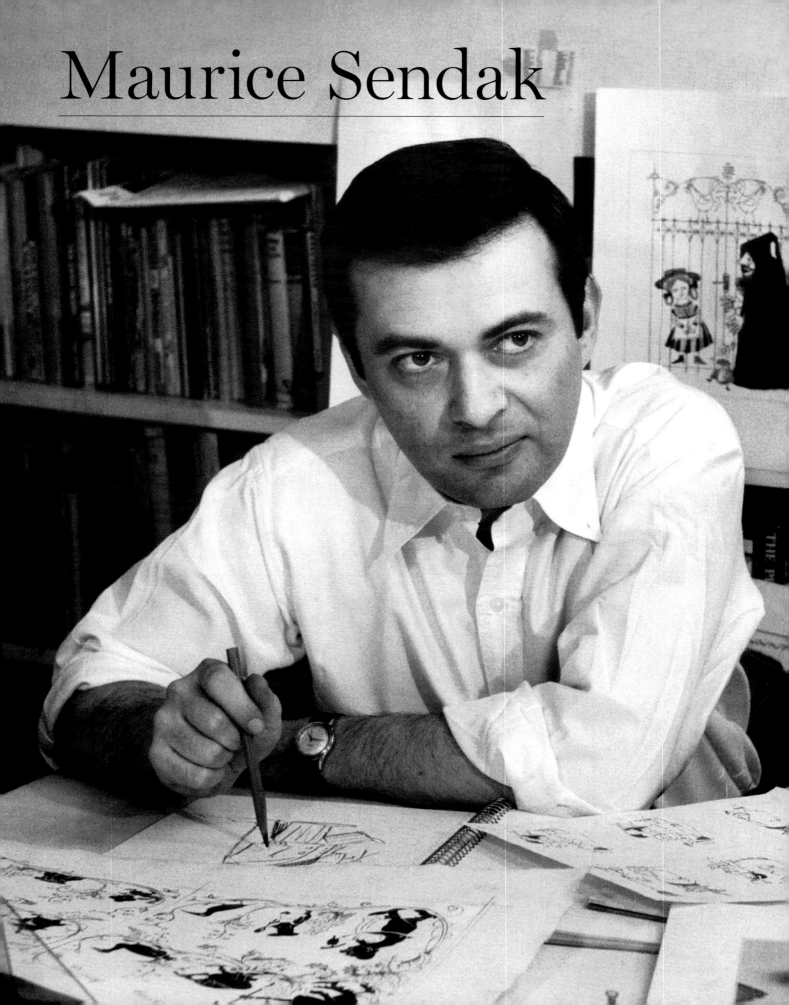

Maurice Sendak

I f the Brothers Grimm had an advantage—after all, there were two of them—this native New Yorker, working solo in both words and pictures, conjured just as compelling a magical realm and spurred just as many nightmares. Maurice Bernard Sendak, who died in May in Connecticut at age 83, reveled in the dark and fearsome. He, along with the equally brilliant Dr. Seuss, was an important player in many of the best modern-day childhoods, beginning with those of the Boomer generation. In the 1950s he began as an illustrator before taking total control of his books; his artwork eventually elevated more than 80 volumes by various writers—volumes that sold nearly 30 million copies around the world. The most celebrated of his masterworks, *Where the Wild Things Are*, sold 19 million by itself.

As with many writers and artists, memory was crucial to Sendak, and since his principal audience was children, memories of his own upbringing informed his narratives. The son of Polish Jewish immigrants, he was sickly as a toddler, and spent most of his time in bed in Brooklyn watching others play. His older sister, Natalie, loving but fulsomely resentful, was forced to take care of him; she would become Ida in Sendak's favorite of his own books, *Outside Over There*. His well-meaning but alarming Jewish aunts, uncles and cousins who had fled Hitler, inspired the *Wild Things* characters. Other influences were a diverse array: comics, Busby Berkeley musicals, the poet William Blake, the terrors of World War II. Sendak's older brother was stationed in the Pacific, Natalie's fiancé was killed, Polish relatives died in the Holocaust: All of this is—somewhere, somehow—in the books.

Expanding on his work in children's literature, Sendak, seen here in 1963, designed for the stage. He created sets and costumes for the Houston Grand Opera production of *The Magic Flute* in 1980, the Pacific Northwest Ballet's version of *The Nutcracker* in 1983, and Houston's *Hansel and Gretel* in 1988. He said that the last, based of course on the Grimms' telling, appealed to him because he was overwhelmed by any abuse of children, and saw this as an opera about neglect. "Why is the fairy tale so famous?" he asked. "Because it's terrifying."

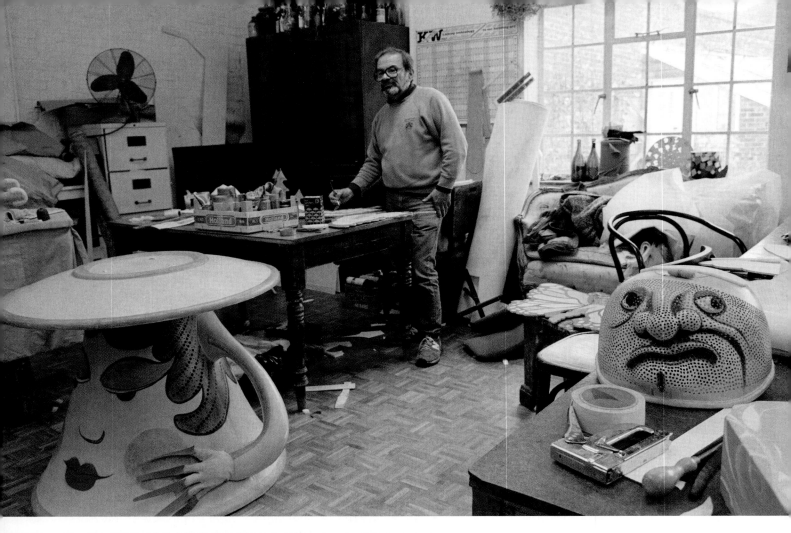

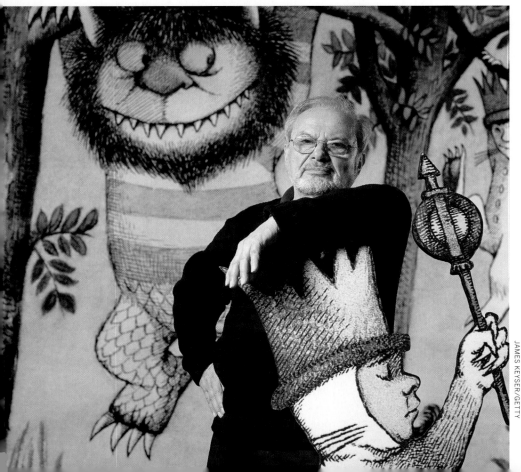

ABOVE: In 1987 in East Sussex, England, Sendak is in the set shop amidst some of his creations for a Glyndebourne Festival Opera production. Left: More recently, he is back in the city of his birth in a life-size scene from *Wild Things;* the Children's Museum of Manhattan is honoring 50 years of Sendak. Delightfully irascible, whenever critics wondered if his work might traumatize, he insisted that a scare could do the kids some good, and if things got to be too much, they could always wet their pants. Nonetheless, he never conquered one of his own fears: Though he had a 50-year relationship with Eugene Glynn, a psychoanalyst, he never dared to tell his parents that he was gay.

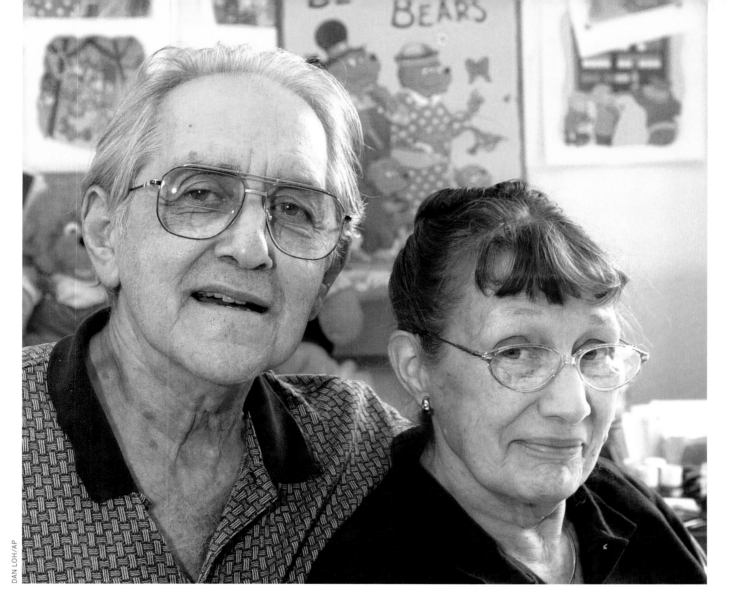

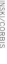

Jan Berenstain

We mentioned briefly in our appreciation of Maurice Sendak the children's book titan Dr. Seuss. He was a real person, Theodor Seuss Geisel, and when he was helping to edit the Beginner Books line at Random House, he took under his wing the author-illustrator team Stan and Jan Berenstain. He coached them on simplicity, and helped them create the Berenstain Bears, a family of eventually five exceedingly kind, moral ursae who became children's literature superstars: over 200 million books sold, plus a TV series and more than 20 television movies. Stan died in 2005, and his widow, Jan, passed away in February in Pennsylvania at age 88. One who was just the right age for both Sendak and Berenstain was Jeff Kinney, who would grow to write and draw the wonderful *Wimpy Kid* sagas, and he told LIFE that a child could go both ways: "I remember flipping through the pages of *Where the Wild Things Are*, thinking, 'Am I really supposed to be reading this?' The illustrations were scary and dangerous, but they were also provocative and alluring. Maurice Sendak trusted his audience to be brave enough to go on the perilous journey with Max and arrive safely back at home, a little better off for having been seasoned by the adventure.

"At the same time, I felt like the Berenstain Bears' tree house was a safe haven. It represented everything that was warm and good about family life, and I spent countless hours rifling through the pages of our dog-eared copies of Jan and Stan's wonderful stories." Countless hours for Jeff . . . and so many other children.

Maeve Binchy

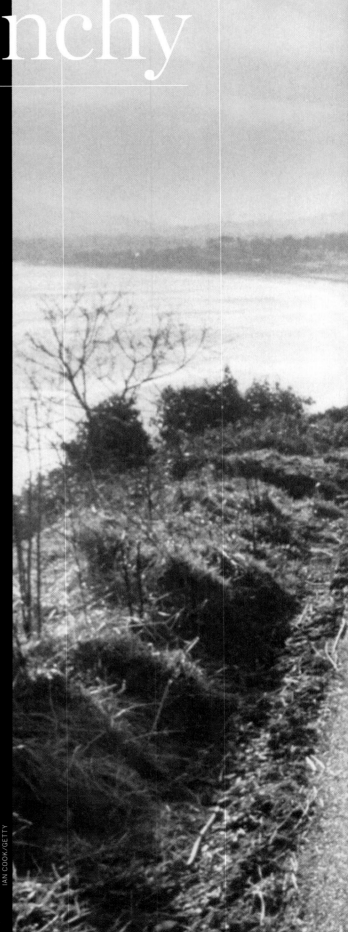

She died in Dublin, aged 72, within a day of Gore Vidal's death in late July—quite as if to point up just how different world-renowned literary luminaries can be.

In some few ways, perhaps, they were alike: They both wrote novels and nonfiction; they both wrote for the stage and for the screen; they both wrote about their native lands and people. But if Vidal needed to be considered aristocratic and of the cultural elite, Binchy was happy to be one with her audience. These divergent desires were part and parcel of who these writers were. The Irish novelist John Banville, a Man Booker prizewinner who is Vidalesque in terms of laurels received and literary respect accorded, made the point when both writers passed away in such close proximity. Vidal, said Banville, "used to say that it was not enough for him to succeed, but others must fail. Maeve wanted everyone to be a success."

Her generosity of spirit translated to the page and gained her a readership as devoted to her as she was to them; in terms of popularity, she dwarfed Vidal: 40 million books sold worldwide in more than three dozen languages, a greater total than those of Wilde, Joyce, Yeats, Beckett or her Irish contemporaries Edna O'Brien and Roddy Doyle. In novels such as *Circle of Friends* and *Tara Road*, she connected with people, and moved them. On World Book Day in 2000, a poll of readers showed her ranked above Jane Austen and Charles Dickens.

In the photograph at right, taken in 1991, she is at the edge of the sea near her home in Dalkey, County Dublin—the place where she was born in 1940 and lived most of her life, including 35 years with her husband, the children's book author Gordon Snell, who survives her. The folks who walked the streets of Dalkey and other Irish villages were the folks she immortalized in her fiction. She wrote about the vagaries and passions of everyday life, and came to love her characters just as much as her readers did.

IAN COOK/GETTY

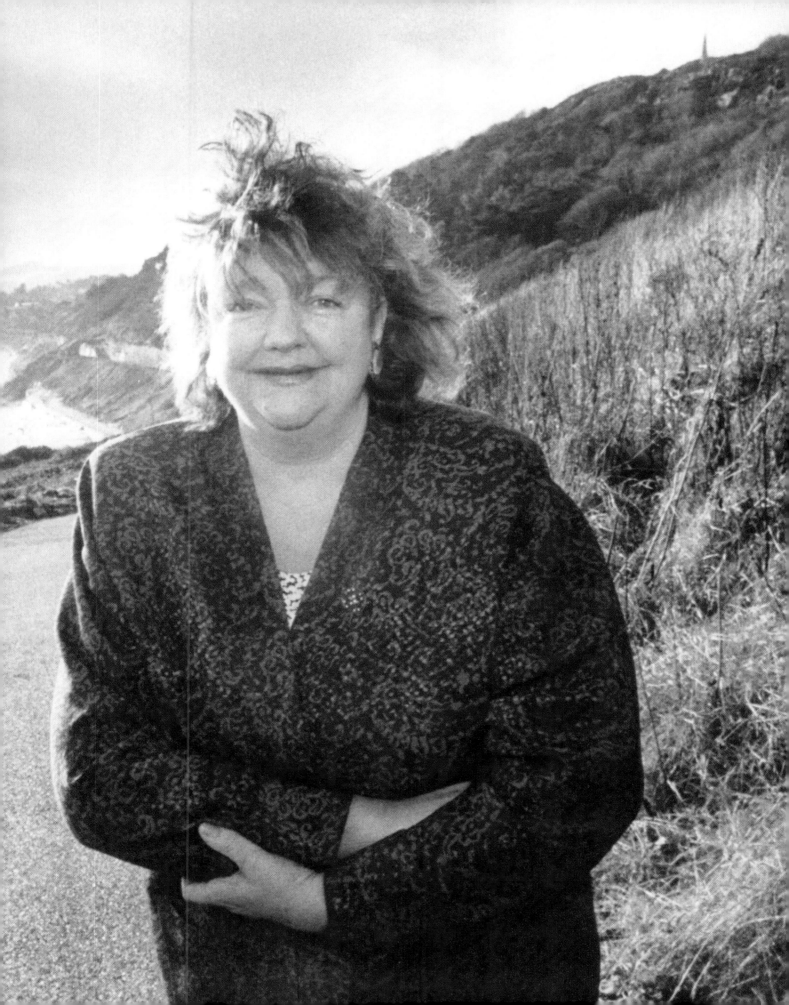

A vigorously political writer of fiction and essays, Fuentes, who died in Mexico City in May at age 83, was more Vidal than Binchy, with a large caveat: He, like Binchy, wrote almost exclusively about, and was always concerned with, his own people—in his case, the people of Mexico, Cuba and elsewhere in Latin America. Fuentes was born in Panama City; his father was a Mexican diplomat, and the boy's upbringing was in Mexico City, various other Latin American capitals and also Washington, D.C. In 1959 he went to Havana to write, admiringly, of the Cuban revolution (he would break with Castro years later), and in the 1960s gained fame beyond Mexico's borders as one of the leaders of "El Boom," the Latin American literary explosion that was co-spearheaded by friends including Gabriel García Márquez and Mario Vargas Llosa. Each of those two eventually won the Nobel Prize in Literature, and it was annually speculated that Fuentes might too. Despite the critical acclaim accorded many of his two dozen novels, particularly his masterwork *The Death of Artemio Cruz*, published in 1962, he never did.

He and his fellow travelers infused their fiction with leftist politics and modernist techniques, including such high-wire acts as magic realism. "In the 1960s, why not?" Fuentes once told *Time* magazine's Tim Padgett. "We were young, bold, infinitely ambitious." Fuentes, who is seen at home in 2003, was also devilishly handsome, and enjoyed celebrated affairs with actresses Jeanne Moreau and Jean Seberg. His nostalgic 1995 novel *Diana: The Goddess Who Hunts Alone* is informed not only by the 1960s, but his relationship at that time with Seberg. Fuentes's second marriage, to journalist Silvia Lemus, lasted until his death.

Fuentes, who taught at several Ivy League colleges in the United States, served for a brief period in the 1970s as Mexico's ambassador to France. But it can be said that he was actively involved in his nation's politics whenever and wherever he put pen to paper—which was, in fact, his mode of writing for more than 70 years. A radical in several ways; a reactionary in at least one.

Carlos Fuentes

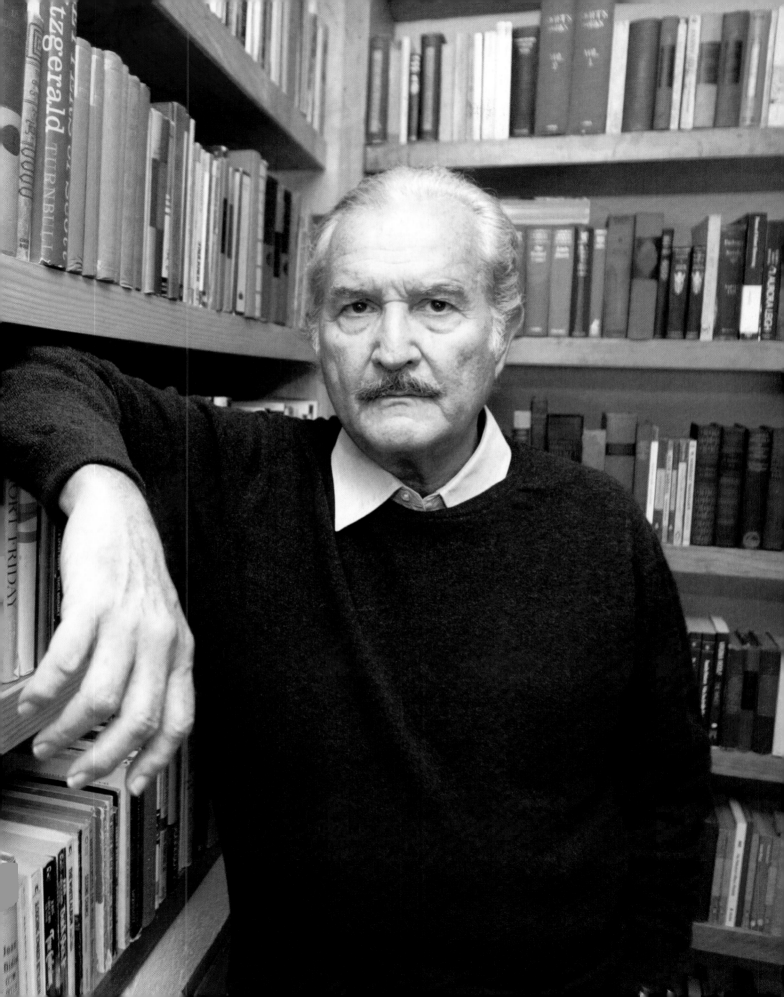

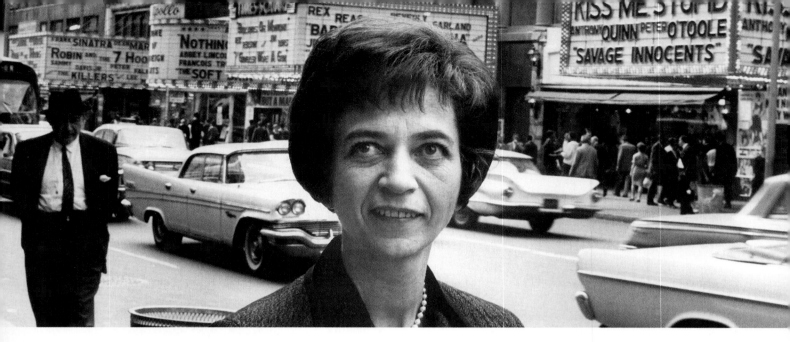

Judith Crist

On these two pages are a pair of New York City–based film critics in their vastly influential heyday. Crist was known from Portland (Oregon) to Paducah to Portland (Maine) for her appearances on the *Today* show and her reviews in *TV Guide* (she was also the first staff reviewer for *New York* magazine), and film cognoscenti might assume that Sarris was the highbrow while she represented vox populi. But in the 1960s and '70s, when the American cinema was exploding with invention—a new golden age of film—it was Crist who terrified filmmakers, even those she championed, such as Stanley Kubrick, Francis Ford Coppola and Woody Allen (she appeared in one of the Woodman's films). Billy Wilder famously quipped that inviting her to critique a movie was "like asking the Boston Strangler for a neck massage." Crist opined that *The Sound of Music* was for moms who think their tots "aren't up to the stinging sophistication and biting wit of *Mary Poppins*." It should be said: She was caustic because she cared. She adored movies; she believed in movies—in movie magic. Crist said the best day of her life was when she cut school to see *Gone with the Wind, The Grapes of Wrath* and *Grand Illusion,* then had money left over to buy an enormous piece of pie. She died in Manhattan in August at age 90.

It's rare for great directors to offer tributes when a critic passes away, but Martin Scorsese sent this to LIFE after Andrew Sarris died in June at age 83: "He changed the way we looked at movies, American movies in particular. And by 'we' I mean all of us, whether we know it or not. He took a French idea—the *politique des auteurs*—and rethought it as 'the auteur theory,' a ringing affirmation of a plain truth: that the person behind the camera could be not merely an interpreter or a traffic cop but an author. This was the key that opened the door to a grand adventure. Andrew was the captain of a ship on an endless voyage of discovery, and everyone who loved cinema was invited aboard.

"I got to know Andrew when I was a young film student. We would always crowd around him at the New York Film Festival screenings, because we all wanted to know what he thought, but even then it was always a conversation with Andrew. He was brilliant, he was passionate, he was inspiring, he was energizing, and his boundless love for cinema was extremely moving.

"Once I started making pictures, our relationship changed, but my respect and affection for him never wavered. When I heard news of his passing, I was saddened by the thought that he would no longer be around to speak up for his beloved cinema.

"Anyone who loves movies owes a lot to Andrew. He gave us something precious and irreplaceable."

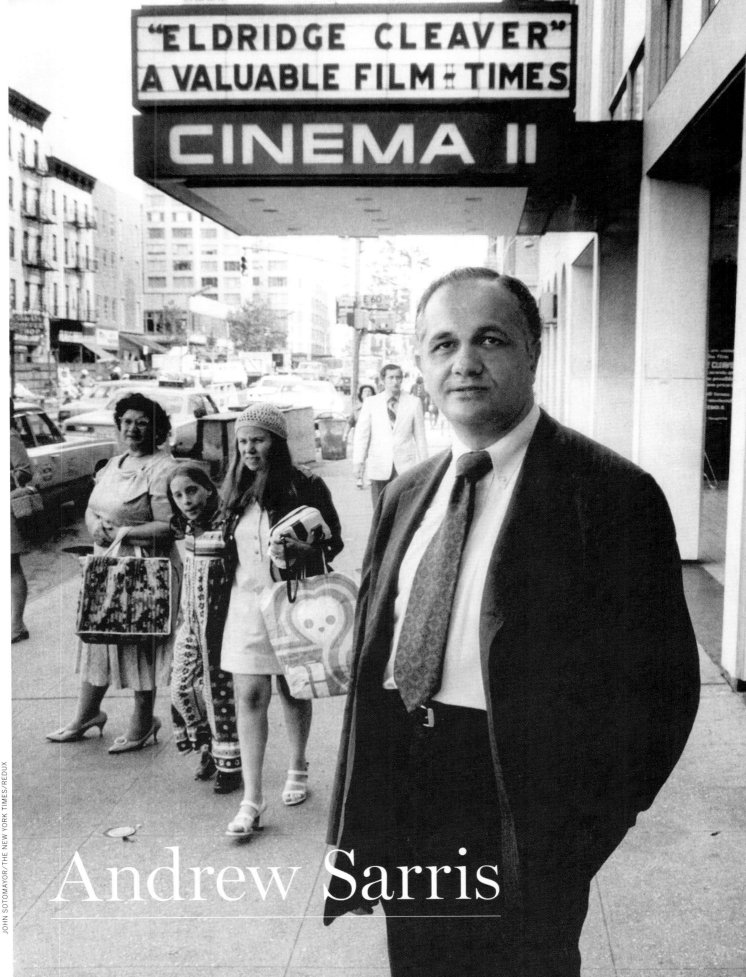

"ELDRIDGE CLEAVER"
A VALUABLE FILM • TIMES

CINEMA II

Andrew Sarris

Paul Fussell

He was a member of and a chronicler of what came to be termed the Greatest Generation. Born in California in 1924, Fussell was a 20-year-old second lieutenant in the U.S. Army when, in 1944, he landed in France with the 103rd Infantry Division. He was later awarded the Bronze Star and two Purple Hearts (he had been wounded in battle in Alsace). Back home, he finished his degree at Pomona College and went on to postgraduate degrees at Harvard. He enjoyed twin successful careers, as an academician and historian. He wrote on literary matters—*Poetic Meter and Poetic Form; Samuel Johnson and the Life of Writing; The Anti-Egoist: Kingsley Amis, Man of Letters*—but it was his books on the two world wars, particularly 1975's *The Great War and Modern Memory*, that made his fame. "What Paul did," said John Keegan, the esteemed British war historian who died only weeks after Fussell, "was to go to the literary treatments of the war by 20 or 30 participants and turn them into an encapsulation of a collective European experience." In a year when the last survivor of World War I also passed away (please see page 26), Fussell's masterwork, which Keegan called "revolutionary," only gains in significance. In latter stages of his career, Fussell's public profile grew even larger as he wrote from the stance of a self-described "curmudgeon" in *Class: A Guide Through the American Status System; Bad: or, The Dumbing of America; Thank God for the Atom Bomb and Other Essays; Wartime: Understanding and Behavior in the Second World War;* and *Doing Battle: The Making of a Skeptic.* Fussell was, early and late, on a crusade to strip war of its romanticism, a crusade he waged until death—at age 88, in Medford, Oregon.

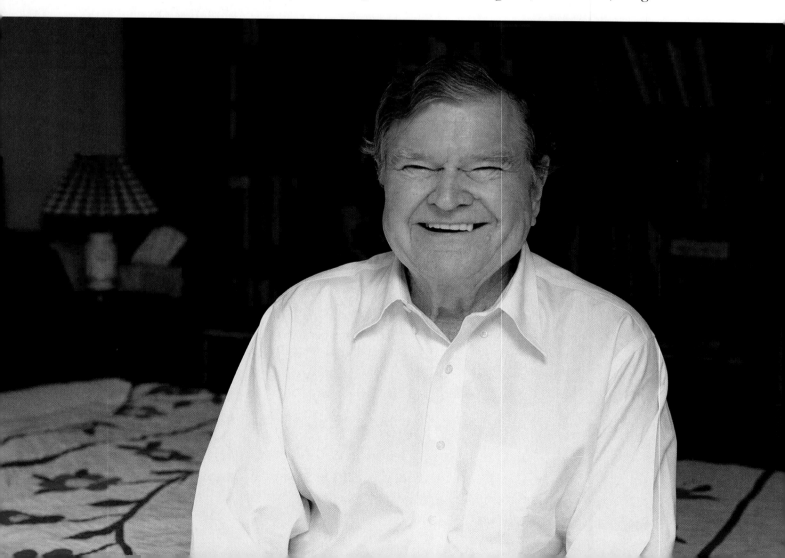

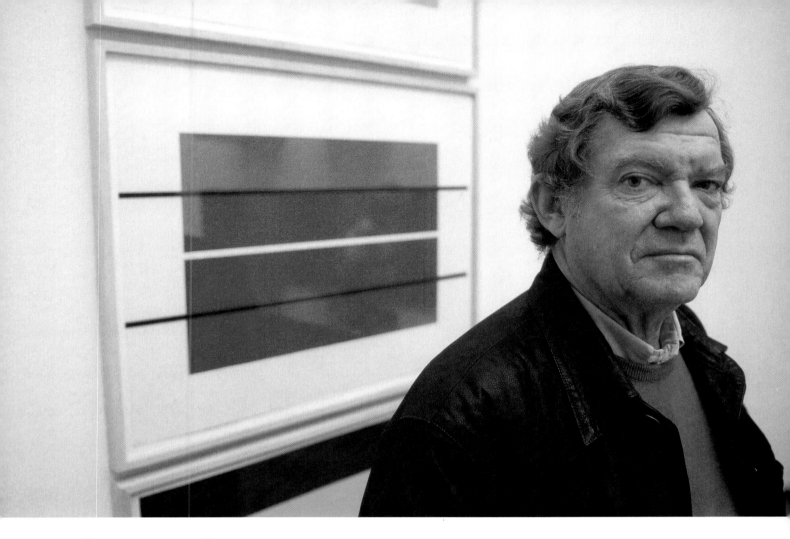

Robert Hughes

When you think "art critic" the persona conjured is not necessarily a rough-hewn Aussie. But Hughes was different from the start, a singular mix of brains, a refined aesthetic sense, an eloquent and elevated writing style and a brawny inclination for battle. Born in Sydney in 1938 to a family with a legacy in the law, Hughes fell in during his college years with other young Australian smarties who would make their mark on a larger stage, including Clive James and Germaine Greer. In his mid-20s, having already written *The Art of Australia*, Hughes decamped to Europe, eventually gaining note in several London periodicals. *Time* magazine made him its art critic in 1970, and his reputation for incisive, sometimes acerbic commentary grew. It became full blown in 1980 with the BBC documentary and accompanying book *The Shock of the New*, which concerned itself with, and aligned Hughes with, modern art. He never really left home, continuing as an ex-pat agitator for Australian republicanism and writing in 1987 his masterly history of British penal colonies, *The Fatal Shore: The Epic of Australia's Founding*, which became a best-seller. It was in Australia, in 1999, that Hughes was involved in a near-fatal automobile accident. He had been tuna fishing the day he crashed his car into another, and, coming to, he recognized the friend who had led the day's expedition, Dan. As they waited for the ambulance, Hughes, trapped in the wreckage, asked Dan to check if the liquid around the car was gasoline. It was, and he asked if Dan had a gun. He had, and Hughes asked him to shoot him if the gas ignited: He would rather die that way. Later, as Hughes was taken away by the EMTs, Dan said, "Bob, you're the bravest man I've ever met." Hughes replied that this was clearly b-s. Dan responded: "Okay, Bob. You're the bravest art critic I ever met."

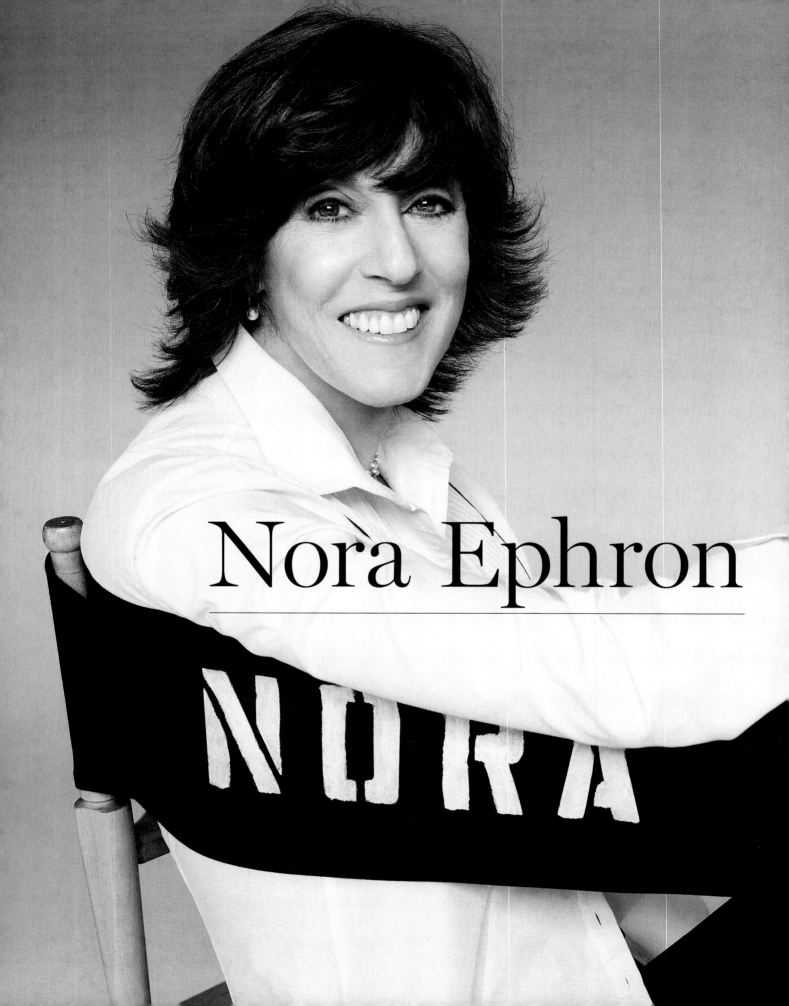

Nora Ephron

Beloved is the word. Her sharp and funny and knowing essays were beloved, her romantic-comedy movies were beloved, the ever-smiling Nora Ephron herself was beloved by her fans—who felt they knew her well, and were correct in the assumption. It can be said that Ephron, a native New Yorker who was raised in Beverly Hills, was to the trade born: Her parents were writers responsible for, among other things, the 1961 Broadway comedy *Take Her, She's Mine*, basing the Elizabeth Ashley character on Nora's letters home from Wellesley College. As Ephron made her way in journalism, she emerged as a deft satirist; her early collection *Crazy Salad: Some Things About Women* remains a treasure. As it had for her parents, Hollywood beckoned, and Ephron would be nominated for Original Screenplay Oscars three times (for *Silkwood, When Harry Met Sally* and *Sleepless in Seattle*) and will be eternally remembered for directing that last film and others, including *Michael, You've Got Mail* and her final, *Julie & Julia*. She also wrote *Heartburn*, a fictional cinematic take on her marriage to Watergate journalist Carl Bernstein that featured Jack Nicholson and Meryl Streep in the starring roles and that engendered threatened legal actions—never launched—by Bernstein. Ephron, widely, truly beloved, was 71 when she died of leukemia in June in New York City.

On these pages, two different crusades—by two different men—that perhaps made the world a better place. In a complicated and convoluted age, Stephen R. Covey created a road map home based on the tangible dividends of character and discipline. His 1989 book, *The 7 Habits of Highly Effective People,* sold more than 20 million copies and encouraged many of its readers to make friends and influence people. Covey was the first to admit that he offered nothing esoteric —"Be proactive" and "Begin with the end in mind" were his primary principles—but he insisted that common sense was uncommon: We needed to focus to behave rationally. A devout Mormon, he kept his faith out of his writing. It certainly was no example of any religious ritual when, in one of his books—about effective families—he wrote that once, in the middle of a business phone call, he allowed his son to spread peanut butter and jelly on his head. (He had a good head for it, as we see in the 1995 portrait at right.) Covey called this a "win-win" situation, since he was able to work and his son certainly had fun. This man who spurred the modern management-book phenomenon, and who died at age 79 in Idaho in July, insisted that his maxims had little to do with business—but everything to do with character.

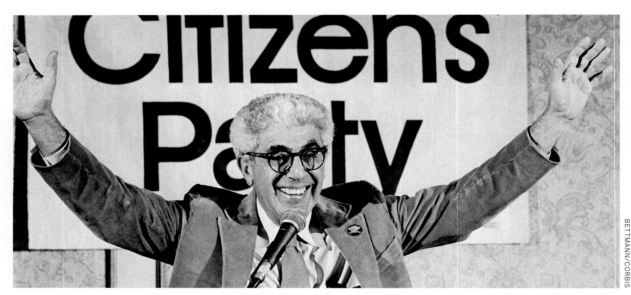

Barry Commoner

The Brooklyn-born biologist, environmentalist and political activist was also, and to no lesser a degree than Covey, dedicated to an adherence to bedrock principles and old-fashioned common sense. His four laws of ecology, as enunciated in his 1971 book, *The Closing Circle,* were Everything Is Connected to Everything Else (all ecosystems are interdependent); Everything Must Go Somewhere (nature has no waste); Nature Knows Best (changes in the natural system are not necessarily improvements, a theory that underlies much contemporary thinking about the food supply as espoused by Michael Pollan and others); and There Is No Such Thing as a Free Lunch (environmental exploitation always has consequences, seen and unseen). Such wisdoms proved, over time, durable and attractive, and the World War II veteran Commoner went from being a college professor to, briefly in 1980, a presidential candidate on the Citizens' Party ticket (he garnered nearly a quarter-million votes). When he died at age 95, he was regarded by those in the know as a pillar of postwar environmental thought and politics. Even those who didn't remember him had been affected by his teachings.

Steve Covey

Ivan Karp

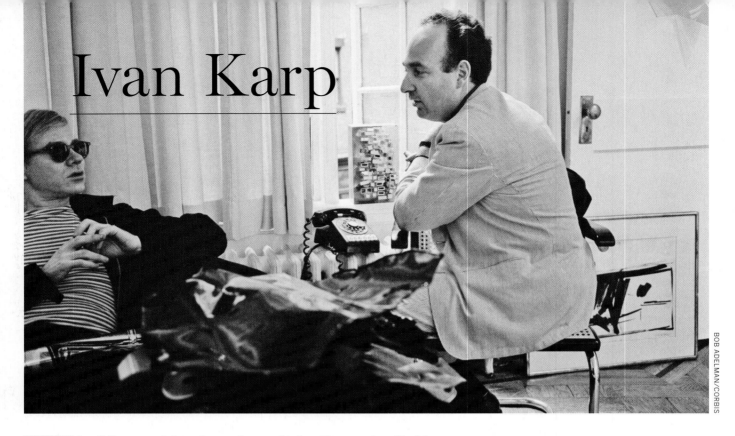

The fellow at right, above, is art dealer Karp, who died in June at age 86, and at left is, yes, Andy Warhol. Karp was a self-described "rubble-rouser," and Warhol was one of the young artists who helped cause the rousings.

Raised in Brooklyn, Karp went to college on the G.I. Bill and was an art critic for *The Village Voice.* He also had stints as a Good Humor ice cream vendor and as a film editor, assigned by New York movie producers to cut distracting kissing scenes from shoot-'em-up westerns. Becoming an art dealer, the cigar-chomping Karp, a consummate salesman, found his calling. In the 1960s, he helped focus public attention on the quirky, happening pop art movement, which might feature portraits of Campbell's soup cans or assemblages of city trash. That cultural epoch allowed people on the fringes to talk to the mainstream, and Karp was a regular guest on such programs as Johnny Carson's *Tonight Show,* where, by championing artists like Warhol, Claes Oldenburg, Roy Lichtenstein and Robert Rauschenberg, he introduced much of America to what was new and what was next. As Karp said in lamenting his hero Vincent van Gogh, "No genius should go undiscovered." He tried to make certain that none other would.

Karp was one of the first to open a gallery in New York's then-gritty SoHo neighborhood, where artists were converting industrial lofts into work and living spaces. By the time Karp retired from the scene, his artists were internationally famous and millionaires many times over, while SoHo had become so trendy that only such as they—and their patrons—could afford to live there.

Barney Rosset

Seen opposite in Greenwich Village's Washington Square Park in 1957 with (from left) Beat Generation poets Allen Ginsberg and Gregory Corso is Rosset, a native Chicagoan who died in February at age 89. He was quite a different kind of New York publisher than, say, Punch Sulzberger, but he was no less controversial. As owner of the progressive Grove Press, he too required the U.S. Supreme Court to affirm his right to publish under guarantees found in the First Amendment. Rosset's ability to print and distribute Henry Miller's red-hot novel *Tropic of Cancer* in 1964 represented a landmark ruling, perhaps as significant as any judicial ruling in American publishing since 1933, when James Joyce's *Ulysses* was allowed in.

Punch Sulzberger

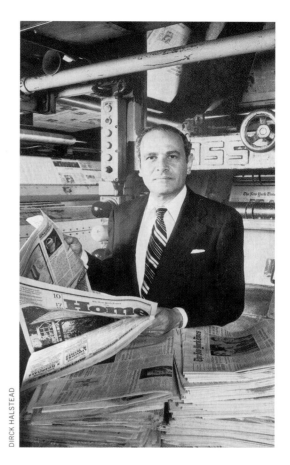

DIRCK HALSTEAD

We remember on these two pages three contemporaneous New York City gentlemen, all World War II veterans, who in their time reflected the astonishing cultural, social, political and philosophical diversity of that great city. At right is Arthur Ochs "Punch" Sulzberger Sr., who, like Karp, died at age 86 this year. A scion of the publishing family that continues to run *The New York Times*, he was a Marine during the Second World War, serving in the Pacific Theater, and as a member of the Marine Forces Reserve was recalled to duty during the Korean War in the 1950s. In 1963 he became, at age 37, the youngest-ever publisher of the *Times*.

Some would say that East Coast liberalism united Karp, Sulzberger and Rosset, and would point to Sulzberger's most famous decision—to publish, over the objections of several of his managers, a series of seven articles based upon the leaked Pentagon Papers in 1971—as proof. Regardless of one's opinion pro or con: The *Times* won a Pulitzer Prize for the series in 1972, and Sulzberger's legacy was cemented.

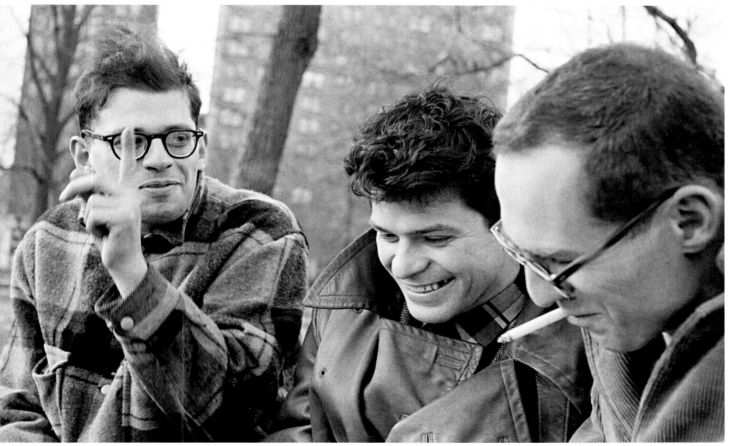

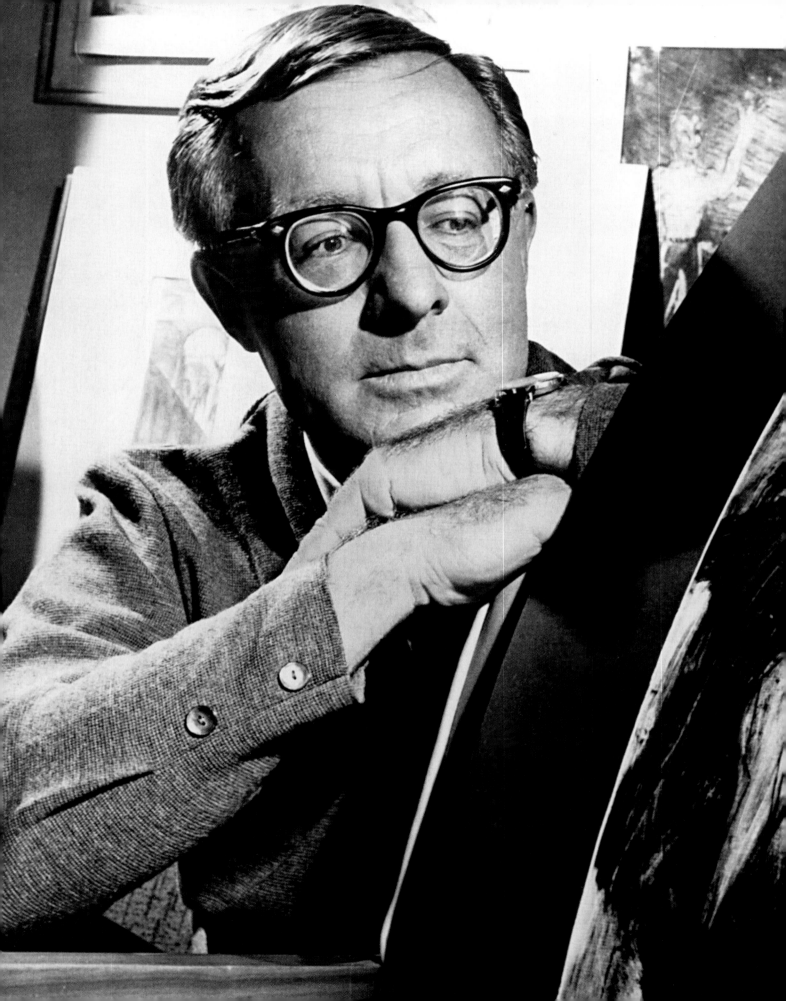

Ray Bradbury

Born in 1920 in Illinois, he was born at the right time. The industrial revolution and several great tournaments of adventure—first man to fly the Atlantic, first to the pole, early efforts at Everest—had sparked the imaginations of fantasists: What might be possible? In the late 19th century, France's Jules Verne led the way to the bottom of the sea and to the moon, and others followed. L. Frank Baum took us—and young Ray—to Oz, and Edgar Rice Burroughs took us—and him— to Tarzan's jungle and John Carter's Mars. Bradbury would prove as smart and entertaining a guide to fantastic realms as any of his boyhood heroes, even including Mr. Electrico.

And who was that?

When Ray was not yet a teenager in 1932, he was captivated by a carnival sideshow featuring an enthusiastic magician. When Mr. Electrico finished his act, he raised his sword and touched the boy, instructing him to go forth and "Live forever!"

"I decided that was the greatest idea I had ever heard," remembered Bradbury. "I started writing every day. I never stopped."

And thereby he did gain, over his 91 years, a kind of immortality. *The Martian Chronicles, Fahrenheit 451, Something Wicked This Way Comes, The Illustrated Man* and many others of his scores of novels and stories will be read forever. The classic movie version of *Moby Dick*, for which he wrote the screenplay, will be seen forever. The wonder and intellectual curiosity he inspired in his millions of readers old and young (here, in 1966, he regards a student's artwork that is meant to illustrate one of his tales) will be handed down.

As he progressed through his long literary life, he was fortunate in many ways. He and his wife, Marguerite, settling in Los Angeles, enjoyed a 57-year marriage; they had children and grandchildren. Bradbury, so directed by Mr. Electrico, continued to write, and his legion of fans will share the pleasure he felt when summing up: "In my later years I have looked in the mirror each day and found a happy person staring back. Occasionally I wonder why I can be so happy. The answer is that every day of my life I've worked only for myself and for the joy that comes from writing and creating. The image in my mirror is not optimistic, but the result of optimal behavior." One more Ray Bradbury pearl for us all.

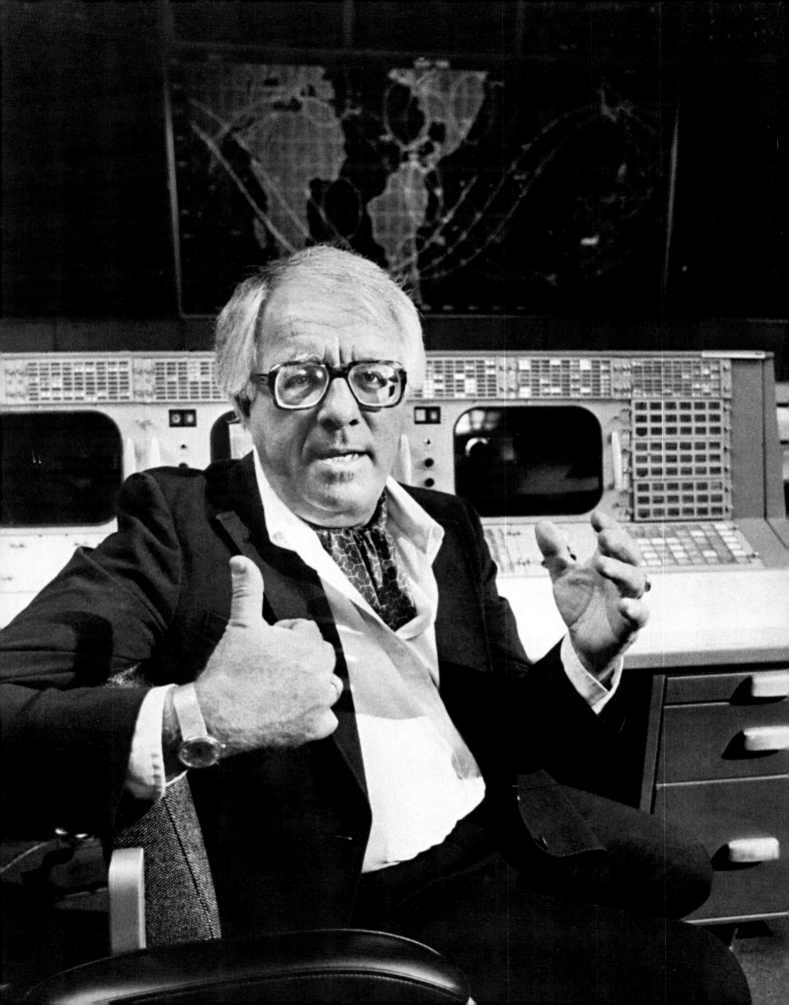

MACHINES INTERESTED HIM; sometimes in his fiction, machines played as active a role as people. On these pages, Bradbury and different machines: in a control room in 1979 (opposite); taking a brief break with a bike ride; and at the keyboard. Here's an interesting typewriter anecdote: In the early 1950s, with a young family, Bradbury sought refuge from the commotion at home by venturing to UCLA's Lawrence Clark Powell Library, where he discovered a basement room "with 12 typewriters in it that you could rent for ten cents a half-hour. And there were eight or nine students in there working away like crazy." Bradbury went to the bank, got a bag full of dimes and returned to the library. With $9.80 worth of half hours behind him, he had completed the short story "The Fireman," which he would later expand into his 1953 masterpiece *Fahrenheit 451.* So the most famous novel ever written about book burning was conceived amidst thousands of books in a library.

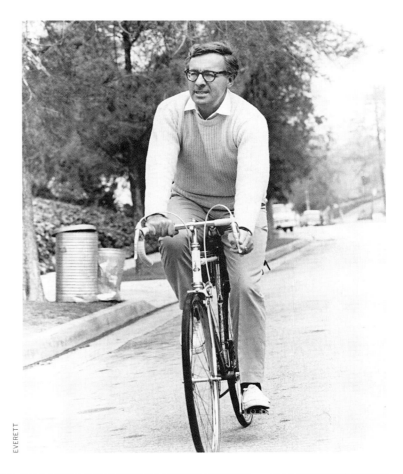

EVERETT

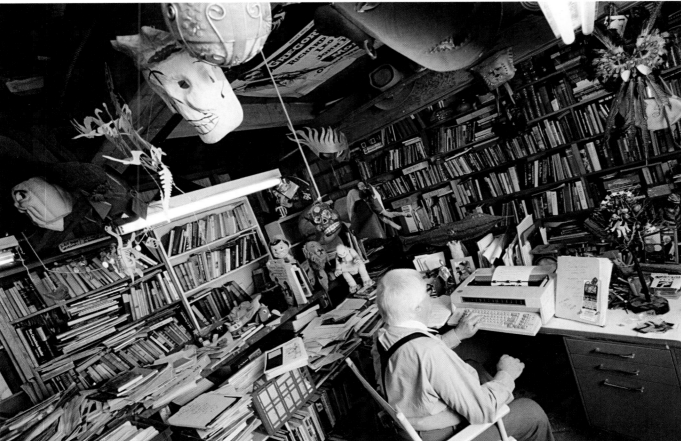

DOUGLAS KIRKLAND/CORBIS

BETTMANN/CORBIS

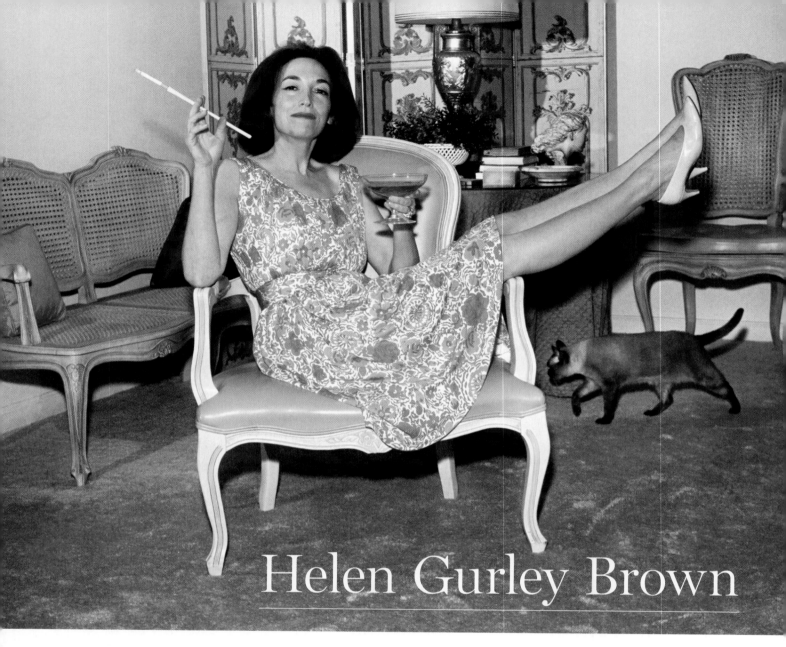

Helen Gurley Brown

Two strong, driven, phenomenally successful magazine editors perceived, exploited and encouraged society's changing sexual mores: Hugh Hefner with his men's monthly, *Playboy,* and Helen Gurley Brown, who is pictured here in her Park Avenue apartment in 1965 when she first took charge of *Cosmopolitan* and set about defining her "Cosmo Girl." The feminist Gloria Steinem later told *The New York Times* that *Cosmo* "became the un-liberated woman's survival kit, with advice on how to please a man, lover or boss under any circumstances," but others were and remain more charitable. Erica Jong, author of *Fear of Flying* and other novels, offered her appraisal of Brown to LIFE: "She showed us that sex and single did not an oxymoron make. She reinforced our toughness. She knew how hard it was for a woman to succeed in a man's world, and she knew we had to use every ounce of energy, talent, brains and looks we had.

"For me, she left a particular legacy. I don't know where she said this, but she encouraged us to treat our husbands like dinner dates, and never let the conversation go stale. I think of this whenever I have dinner with my husband, and it is really helpful. I never want us to be one of those couples who stare into their soup bowls as if they would like to jump into them. Everything Helen taught us was against entropy. She was a great spirit underneath her 'Hello Kitty' demeanor." Helen Gurley Brown, who maintained to the end that there was nothing good or glamorous or noble about growing old, was 90 when she died in August.

LeRoy Neiman

He was as colorful as his paintings, which was colorful indeed. With splashes of vibrant primaries that rivaled in their age those of pop artist Peter Max— which man sold more prints or posters would be an interesting question—the native Minnesotan became famous for his renderings of star athletes and for his work in *Playboy*. Hugh Hefner warmly remembered his late friend, who died in June at age 91, for LIFE: "LeRoy Neiman was the official house artist of *Playboy*. He blended commercial and fine art, which is what I wanted for the magazine. I knew he would be okay because when I worked as a copy writer at Carson Pirie Scott department store, he was an illustrator there and at the same time was teaching at the Art Institute. Within a month of starting *Playboy*, I ran into him and discovered that his apartment was near our offices. He began to work for us, initially creating the Man at His Leisure series. We sent him around the world to illustrate the definitive nightclub, which led him to meet celebrity sports figures. It all began with *Playboy*, but his sports connection became just as important.

"One of the things that is not so well recognized is *Playboy*'s influence on commercial art. Instead of Norman Rockwell, photograph-like illustrations, we ran impressionistic, semiabstract art in a wide range of styles that defined the era. Only a handful of people who were contributors to the magazine were also personal friends of mine and LeRoy Neiman was one of them."

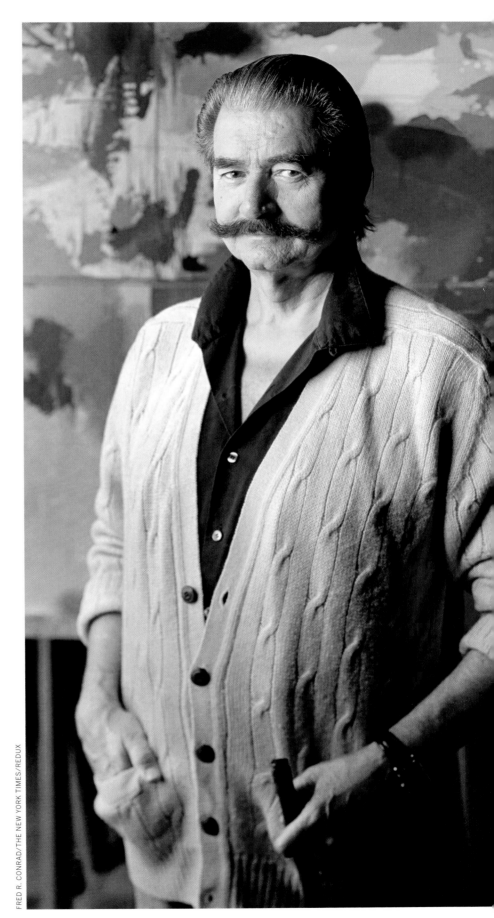

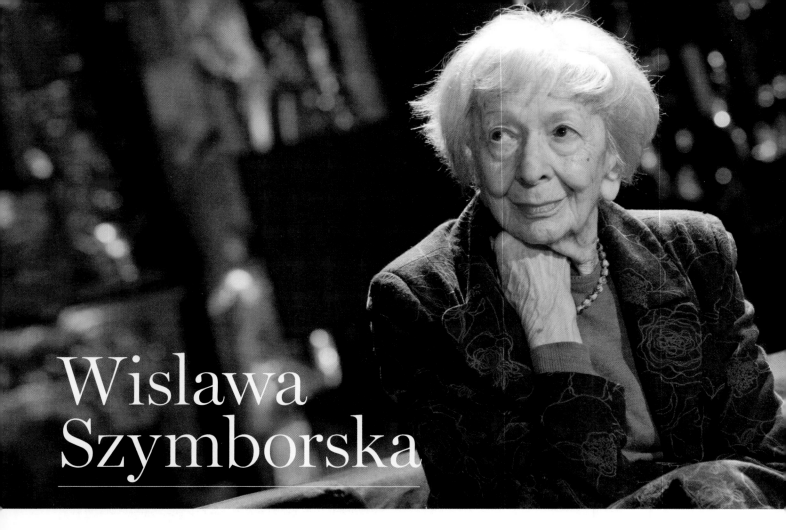

Wislawa Szymborska

The former U.S. poet laureate Billy Collins sent this eloquent tribute to LIFE after Szymborska died in Krakow at age 88: "When Wislawa Szymborska won the Nobel Prize in Literature in 1996, the world of poetry was taken by surprise. At the time, she was relatively unknown outside her native Poland, where she was revered—plus she was 73 years old. Since then, she has become canonical, a household name everywhere poetry is read. What first attracted so many—including me—to her poetry and what played a big part in her sudden rise to prominence was the tone of her poetic voice, which blends sincerity and wit so well as to cause readers to wonder which tone is the real one. The answer, of course, is both. Fond of handling the deadly serious with a touch of whimsy, Szymborska tended to enter her poems without knocking. 'Don't take jesters into outer space,' seems like a sudden and even silly beginning, but that poem goes on to show how dark, infinite space can make us lose our sense of humor.

"Making wild imaginative leaps by using only simple diction and straightforward sentences, her poems are equally profound and approachable, disturbing yet charming. One poem praises her sister for not writing poems ('I feel safe beneath my sister's roof'); in another, the discovery of a new star is given a human context when it is spied between a cloud and a twig on a shrub. When the poet has to take an examination in 'History of Mankind,' a monkey in a Brueghel painting prompts her by gently clinking his chain.

"By uniquely combining a genius for bizarre conceptual shifts with a deep devotion to what makes us human, Szymborska invited us to reconsider our understanding of 'poetry,' and that could be the ultimate measure of a truly major poet. She published fewer than 350 poems in her lifetime but enough to provide many worlds of delight and illumination to her lucky readers; it is our keen loss that she will write no more."

Erica Kennedy

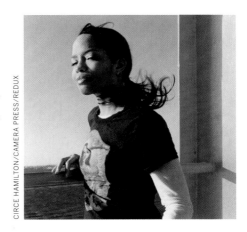

CIRCE HAMILTON/CAMERA PRESS/REDUX

This photograph represents a portrait of the artist as a young woman, riding the Staten Island Ferry in New York City in 2005. Sadly, the artist would not grow very much older: Erica Kennedy Johnson, the blogger, social media maven and novelist—a kind of post-modern literary lioness—was found dead in June in her Miami Beach apartment. The author of the best-selling *Bling* and also *Feminista*, which have been credited with elevating chick lit, as well as giving it an African American face, was only 42 years old.

DAMIAN KLAMKA/POLARIS

BETTMANN/CORBIS

Adrienne Rich

Billy Collins admitted that the great poet Wislawa Szymborska snuck up on many Americans, fellow poets included. Adrienne Rich, who died in March at age 82, snuck up on no one—although important aspects of her personal history, which deeply informed her art, became known only over time. Born in Baltimore to privilege, she had talent that was recognized early by none other than W.H. Auden; when she was 21 her first collection won the Yale Younger Poets prize. (In the photograph above, she is at Yale in 1966 as one of several literary figures who have gathered to pay tribute to the late poet Randall Jarrell.) She graduated from Radcliffe, married a Harvard professor, had children and continued to write. But she found herself growing increasingly self-aware, and also buffeted by the winds of change. She drifted to leftist causes, even to support of the Black Panthers, and eventually separated from her husband; he would later commit suicide, while she would become one of American letters' foremost voices for feminist and lesbian causes ("My politics is in my body"). Adrienne Rich once wrote: "We are, I am, you are / by cowardice or courage . . ." It was a challenge to her many devoted readers, and certainly to herself.

Martine Franck

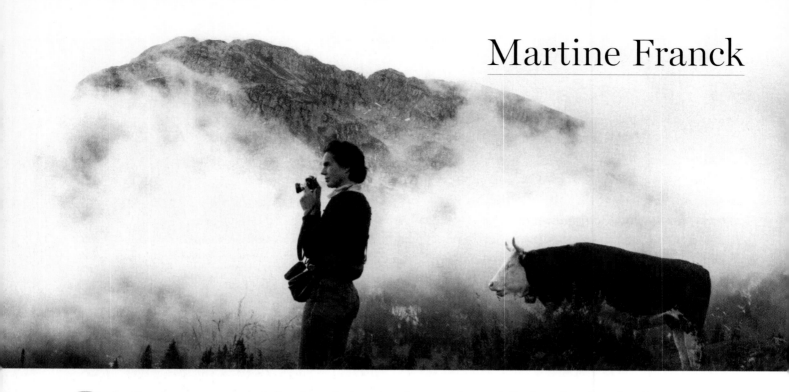

On these two pages: storied, talented photographers, and certainly therefore friends of LIFE, whose work has appeared through the years in our pages. Franck was born in 1938 in Antwerp, Belgium, into a well-off family—but not, since Hitler was on the march, into comfortable circumstances. The family relocated almost immediately to London. Franck's father enlisted in the British army and her mother took the rest of the family farther west to the United States for the duration of the war. Her parents were art lovers, and in her teens Franck hoped to one day be a curator. But she drifted toward photography, and worked in the early 1960s for LIFE staffers Eliot Elisofon and Gjon Mili. She was shooting the fashion shows in Paris for *The New York Times* in 1966 when she met the legendary photography pioneer Henri Cartier-Bresson, who made the photograph of Franck seen here in 1984. They married, despite an age difference of 30 years, in 1970. Through the years Franck photographed for every periodical from *Vogue* to LIFE to *Sports Illustrated,* and along with Eve Arnold, she was one of the few women to be accepted as members of the noted Magnum photo agency. She was 74 when she died in Paris.

Eve Arnold

SNOWDON/CAMERA PRESS/REDUX

Arnold, who was born Eve Cohen in Philadelphia in 1912 and died at age 99 in London, was, like Cartier-Bresson, a pioneering photojournalist during that profession's first great century. Her interest in picture taking began in New York City in the postwar years, and she went on to chronicle the plight of the dispossessed as well as the intimate lives of the fabulous and famous, such as Marilyn Monroe, Joan Crawford, Queen Elizabeth II—and also Malcolm X. "I don't see anybody as either ordinary or extraordinary," she told the BBC in 1990. "I see them simply as people in front of my lens."

Malcolm Browne

O n this page are two photographers who distinguished themselves with their work for the Associated Press during the Vietnam War. Browne, right, born in New York City in 1931, was greatly influenced by his Quaker mother, who was a pacifist. After graduating from a Quaker college, Browne was drafted into service during the Korean War and began his career contributing to *Stars and Stripes*. He was awarded a Pulitzer Prize for his work in Indochina in 1964, which included a famous photograph of the self-immolation of a Buddhist monk. He later worked for *The New York Times*, and in the early 1990s covered his last war: the first Persian Gulf War. He was 81 when he died in August of complications from Parkinson's disease.

Horst Faas

B oth of the photos seen here were taken in 1965 in South Vietnam; Browne is pictured on patrol near Hoa Binh, while Faas is seen conversing with a soldier at Phuoc Vinh. Born in Berlin, Faas twice won the Pulitzer Prize, first for his work in Vietnam and then again, in 1972, for his coverage of the situation in Bangladesh. While rightly praised for his own photography, Faas was also vastly influential as a picture editor. He was largely responsible for the decision to release for publication not only Eddie Adams's shot of a Vietcong prisoner being executed in the streets of Saigon, but Nick Ut's "Napalm Girl" image. Faas was 79 when he died in Munich in May.

Warm. Perry Como sang as warm as a sweater, and so did Andy Williams. He had a warm personality as well, and was very handsome. All of this combined in the 1960s to make him one of America's most popular singing and television stars, and in latter years to allow him to continue as an entertainment eminence, even icon. In an episode of *The Simpsons*, Nelson Muntz, a diehard Williams fan, cried earnestly as the singer performed his signature song at his (real-life) Moon River Theater in Branson, Missouri. Viewers who were just as devoted as Muntz understood completely.

He was born Howard Andrew Williams in Iowa in 1927 and by the time he graduated from high school, the family had relocated to Los Angeles, where he and his three older brothers, Bob, Don and Dick, continued with a singing act they had formed: The Williams Brothers. When Andy was still in his teens, he and his siblings began appearing in musical films, and they backed Bing Crosby on the 1944 hit version of "Swinging on a Star." Kay Thompson recruited them as her backup singers, and by the time Andy turned 20 he was part of the biggest nightclub act in the world. Thompson became Andy's lover despite being almost twice his age, and later in the 1950s, after the group had dissolved, continued to mentor his solo career.

Which found quick success. Williams was a natural for TV, and regular appearances on Steve Allen's *Tonight!* show led to occasional specials and then to his own long-running (1962–71), immensely popular variety show. In the meantime, there were the hits, most of them gems of middle-of-the-road balladry. Interestingly, the 1961 Johnny Mercer–Henry Mancini composition "Moon River" was never an Andy Williams single, though his became the definitive version and his signature song every bit as much as, say, "I Left My Heart in San Francisco" is Tony Bennett's.

Williams became known as Mr. Christmas for his several holiday albums and annual TV offerings featuring his family (here in 1965, with wife Claudine Longet, the French singer he married in 1961 and divorced in 1975). Certainly this Christmas season, Andy Williams hymns and carols will be played on regular occasion, and the fans will remember him—warmly.

Andy Williams

Two children of New York City, Marvin Hamlisch of Manhattan and the famed Juilliard School of Music and Barbra Streisand of Brooklyn and the musical theater, first came together when young Hamlisch's first professional job was as the singer's rehearsal pianist during preparations for *Funny Girl*. That show would make Streisand famous, and Hamlisch's renown, particularly in the industry of their mutual choosing, would follow. When Hamlisch died in August at age 68 of a respiratory ailment, he was one of only two people to have won an Oscar, an Emmy, a Tony, a Grammy and the Pulitzer Prize. In his company: the legendary Richard Rodgers.

He was a keyboard prodigy of the Mozart model, accepted into Juilliard's precollege program when he was seven. Like Streisand, he was passionate about classics of the American Musical: *My Fair Lady, Gypsy, West Side Story*. He co-wrote a Lesley Gore pop hit when he was 21 and scored his first movie, *The Swimmer*, based on the John Cheever story, at age 24. A fun footnote before we move on to the work for which he will be remembered: He wrote the zippy, pitch-perfect music for Woody Allen's early comedies *Take the Money and Run* and *Bananas*.

The edited résumé, under Films: *Ordinary People, Sophie's Choice, The Way We Were* (Streisand singing the title song), the adaptation of Scott Joplin's ragtime music for *The Sting*, "Nobody Does It Better," the theme song for the James Bond film *The Spy Who Loved Me*. And on the stage: *They're Playing Our Song, Smile* (in this photograph, harmonizing with cast members during rehearsals in 1986) and, most particularly, the transcendentally brilliant *A Chorus Line*. At the time of his death, he was putting finishing touches on a stage adaptation of Jerry Lewis's *The Nutty Professor*.

The lights of Broadway went dim—not just figuratively—when Hamlisch died, and Liza Minnelli, Aretha Franklin and of course Streisand sang at his memorial. "I'm devastated," she said upon hearing of her friend's passing. "He's been in my life ever since the first day I met him in 1963 . . . He played at my wedding in 1998 . . . Just last night, I was trying to reach him, to tell him how much I loved him, and that I wanted to use an old song of his, that I had just heard for the first time."

Marvin Hamlisch

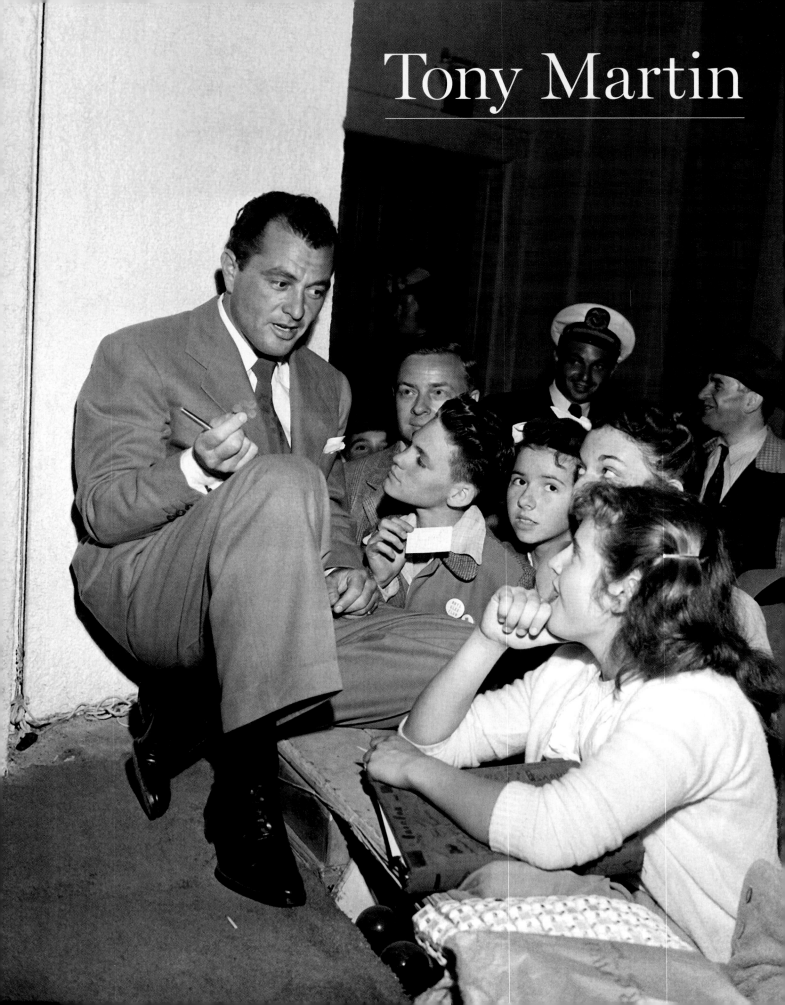

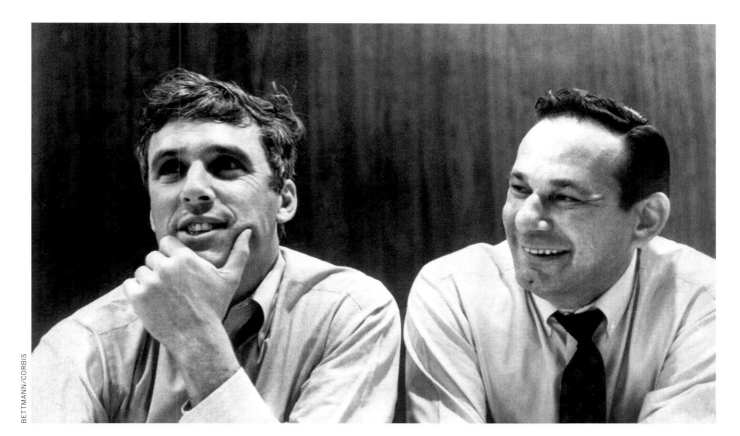

BETTMANN/CORBIS

CBS PHOTO ARCHIVE/GETTY

Sandwiched between the world-beating successes of, first, Bing Crosby and then Frank Sinatra in the mid-20th century were the careers of several other wonderful singers, including that of Martin, seen here signing autographs for his female fans after a performance at the CBS Radio Theater in Hollywood in 1946. His was a sizable popular fame: movie roles in vehicles starring folks from Fred Astaire to the Marx Brothers, literally dozens of hits in the 1940s and '50s, featured roles on the highest-rated radio and TV programs. The handsome Martin was a regular on *The George Burns and Gracie Allen Show* on radio, routinely driving Gracie nuts with desire ("Oh, Tony, you look so tired, why don't you rest your lips on mine?"), and in the mid-1950s hosted a variety series of his own, *The Tony Martin Show*, that was a lead-in to the nightly newscast. The native San Franciscan was married twice, each time to a famous woman: for a few years to the actress Alice Faye, and for 60 years to the actress and dancer Cyd Charisse, who predeceased him in 2008. Martin was 98 years old when he passed away in July.

Hal David

The revered composer Burt Bacharach, seen above at left, was of course generous when asked about his late partner, who died at age 91 in Los Angeles in September. "It was my great fortune to have ever crossed paths with Hal David," Bacharach said. "He was a great writer of lyrics. If you need proof, just listen to the lyrics of 'A House Is Not a Home' or 'Alfie,' and that would be as good as you can get." Indeed—and so were the words to "Raindrops Keep Fallin' on My Head," "What the World Needs Now Is Love" and dozens more. Born in Brooklyn, David served in the military during World War II and then, returning home, made his way to Manhattan's Brill Building, legendary breeding ground of pop songsmiths. He first teamed up with Bacharach in the late 1950s and their pairing was more than propitious—it was kismet. Perry Como and Frank Sinatra recorded their tunes, and in the 1960s they wrote hits for Dusty Springfield, Tom Jones and particularly Dionne Warwick, their foremost interpreter.

Dorothy McGuire

L ike other famous girl groups in the annals of pop music, the McGuire Sisters began singing together in a choir, but it took a good dose of adolescent willfulness to come down from the loft at the First Church of God in Miamisburg, Ohio. Their dad, a guitar-playing steel worker, and mom, an ordained minister at the church, forbade secular music in the home. But the girls— Christine, Dorothy and Phyllis—furtively tuned in to radio stations that would often spin their favorites, the Andrews Sisters. Having harmonized for God, they longed to sing for country, and their parents eventually caved. The McGuire Sisters segued from hymns to pop tunes in performing with the USO, then took a shot at New York. They won a competition on Arthur Godfrey's radio show, which was essentially the *American Idol* of the time, and remained as regulars on the program for six years. They had a slew of hits and appeared before five Presidents and Queen Elizabeth II before retiring the act in 1968. Dorothy, the middle sister and the first to pass on, was 84 when she died this year. In these pictures, the erstwhile choir girl is breaking out in the 1940s.

Whitney Houston

A few pages ago we mentioned that singer Dionne Warwick was a muse for songwriters Burt Bacharach and Hal David. She also inspired her young cousin Whitney Houston—as did, certainly, Whitney's mother, the soul and gospel singer Cissy Houston, and several others. "Being around people like Aretha Franklin and Gladys Knight, Dionne Warwick and Roberta Flack, all these greats, I was taught to listen and observe," said Whitney. "It had a great impact on me as a singer, as a performer, as a musician. Growing up around it, you just can't help it. I identified with it immediately. It was something that was so natural to me that when I started singing, it was almost like speaking."

She started singing in the New Hope Baptist Church in Newark, then with her mother in clubs across the Hudson River in New York City. She was a natural, and she was beautiful: a pop-soul wonder who, in the latter half of the 1980s, topped record sales that had seemed insurmountable only yesterday. The movies beckoned, and with 1992's *The Bodyguard*, Whitney became the latest queen of Hollywood as well.

Substance abuse was her principal of several demons, and when she died in February at age 48 many questions centered on drugs. The paterfamilias of pop, Tony Bennett, made headlines when he weighed in on that front. Lost in the furor was his deeper opinion of the singer herself, whom he called simply, "the magnificent Whitney Houston."

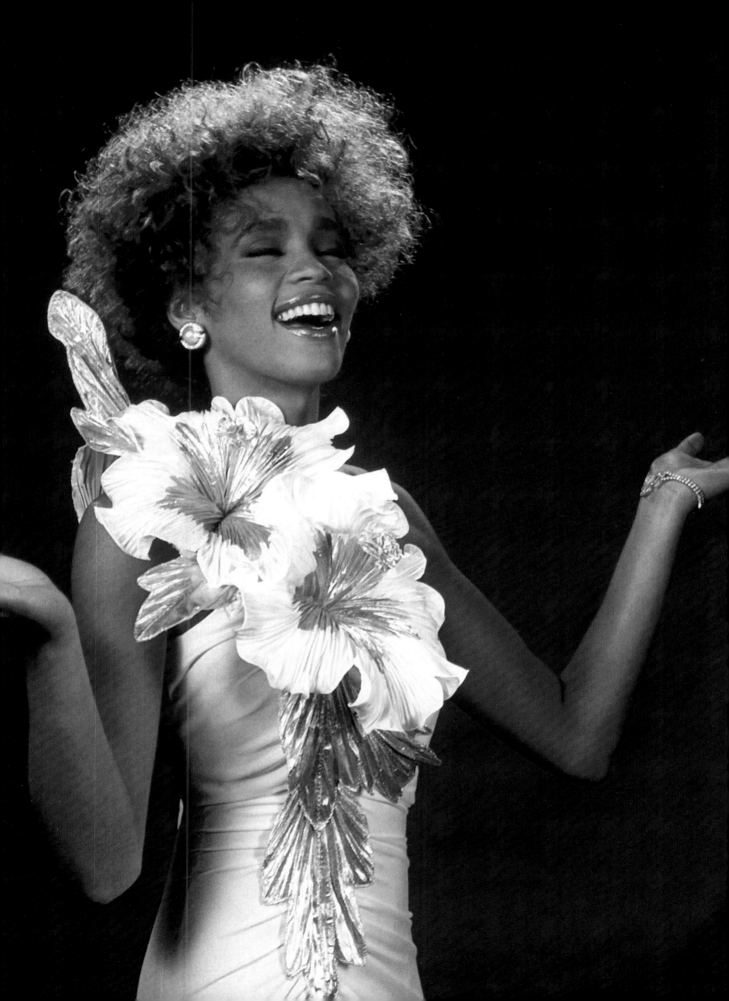

The native Californian, who died in the Golden State in January just days ahead of her 74th birthday, had several things in common with Whitney Houston: an otherworldly voice; a start in a Baptist church choir; an ability to transcend genres, from gospel to soul to rock 'n' roll; at one point, a serious drug addiction. But Jamesetta Hawkins eventually overcame her problems, and went on to a long and ultimately triumphant career that unfolded in chapters: Etta ascendant; Etta down and out; Etta James reborn.

Emerging from a childhood spent in a series of foster families, having endured abuse at the hands of her choir director, James had her first success in 1955 with a rhythm-and-blues number she co-wrote, "Dance with Me, Henry." When the song became a bigger crossover hit under another title for another singer, Etta was upset. By the early '60s she had switched labels and was making her mark with a string of strong singles, including what would become her signature song, "At Last." She went into eclipse, then came back—not for the last time. In 1978 she opened for the Rolling Stones, then spiraled into another decade lost to drugs and booze.

In 1989 she released the album *Seven Year Itch* and, remarkably, Etta James was with us yet again. The awards piled up and the shows were sellouts (here, on stage in Seattle in 1994). Through it all, she exhibited the feistiness—the toughness—that had sustained her and that made her performances so very real and moving. When Beyoncé was chosen to sing "At Last" at Barack Obama's 2009 inauguration, Etta James let it be known that she was hurt that she hadn't been invited to perform her own song. Brassy to the end, she said that she could have done it better.

Etta James

Donna Summer

W hitney Houston was often called a pop diva, Etta James was called a blues diva, and when it came to disco divas, of which there were more than a few, none could top Donna Summer. The native Bostonian LaDonna Andrea Gaines, born on New Year's Eve in 1948, also—like Whitney and Etta—began singing in a church choir. She, too, shone bright and early, and when still a teen she auditioned for a touring company of the rock musical *Hair* and was off to Europe. There, in West Germany, she married a man named Sommer. Not long thereafter, she crossed paths with songwriter Pete Bellotte and producer Giorgio Moroder, the latter of whom historically shoulders a lot of the credit (or blame) for the disco sound, rhythms, ethos—the whole megillah. The two men were wowed when they caught her recording backup vocals at a Blood, Sweat & Tears session, and stardom quickly followed. "Love to Love You, Baby," co-written by Bellotte and Summer, was an extended—17-minute!—bump and grind to rival Ravel's "Bolero," and it was the sound of '76.

Summer, like James and Houston, won multiple Grammys, and an Oscar to boot. Like Houston, she shattered records as she saw three consecutive double-disc albums go to No. 1. Only the brothers Gibb, one of whom we will meet on the following page, rivaled her as disco royalty. "Bad Girls," "Last Dance" and "She Works Hard for the Money" were monster hits, and "I Feel Love" was earth-shaking and groundbreaking; Moroder has said that its groove was the pioneering sound for all electronic dance music to follow.

Donna Summer, once the high priestess of sonic soft-core, became a born-again Christian later in her life. She continued to sing and her fans remained devoted, but in recent years she came up against cancer. She was only 63 years old when she died.

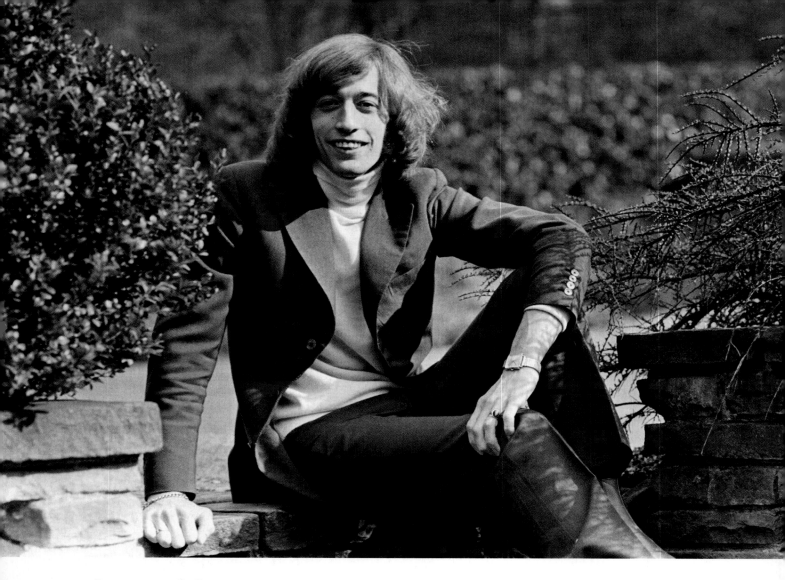

Robin Gibb

The Bee Gees and Donna Summer were inducted into the Dance Music Hall of Fame on the same night, and all fans of popular music might agree: That was as it should be. Just as much as Glenn Miller or Chubby Checker before them, they got us moving.

This could never have been predicted of England's Gibb brothers: Barry and the younger twins, Maurice and Robin. Their early hits in the 1960s were heart-tugging pop ballads such as "New York Mining Disaster 1941," "To Love Somebody," "I've Gotta Get a Message to You" and "I Started a Joke," tremulous lead vocals on the more bathetic numbers often sung by Robin. They had a good go, but it certainly looked like they had played out the string when they starred in the justly forgotten film version of *Sgt. Pepper's Lonely Hearts Club Band*. Then, in perhaps the most successful and surprising self-reinvention in pop music history, the Bee Gees were back on top, bigger than ever, the undisputed kings of disco. "Jive Talkin'" and the multiple hits from the *Saturday Night Fever* soundtrack—"Stayin' Alive," "Night Fever," etc.—were not only riveting, they were fantastic.

Robin, who continued to perform occasionally with his brothers and write music on his own (pop hits for Diana Ross and Barbra Streisand, but most recently: classical), settled into a quieter life on his English estate. Later life would not be kind to the Bee Gees: Maurice died in 2003, and Robin succumbed to cancer and intestinal problems in May at age 62.

usical genres come and go, some more durable than others. We have had many variations of rock 'n' roll for well over a half century now, and certainly disco lives on in some of today's popular music, as does folk, country and western, and Tin Pan Alley—not to mention jazz. Movements that emerged in the wake of disco included belligerent punk and, from the streets, rap and hip-hop. Many of the biggest rap stars, particularly in the early going, were African American. And then there were the Beastie Boys.

They started as a punk band but by the time they released their first album, the phenomenally successful (9 million copies in the U.S.) *Licensed to Ill* in 1986, they were fronted by a trio of MCs/rappers/musicians from New York City's outer boroughs, including Yauch, son of a Catholic father and Jewish mother, who was suddenly better known by his stage name MCA. His was not the usual hip-hop pedigree, to be sure, nor was the course he chose in a life that became dedicated to Buddhist causes, particularly the Free Tibet movement. The Beastie Boys, an entity for a quarter century, produced seven mega-selling albums and were inducted into the Rock and Roll Hall of Fame in April of this year. A month later, Yauch died of cancer at age 47.

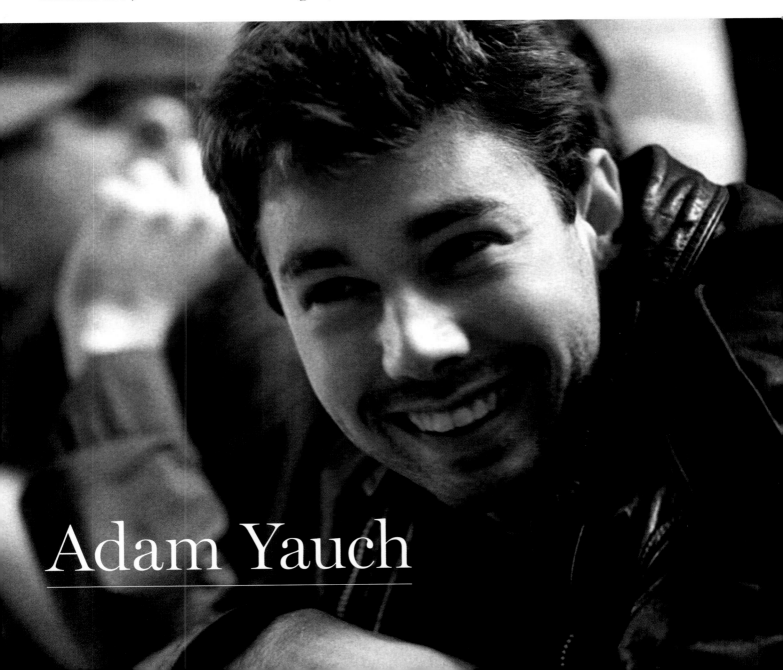

Adam Yauch

Dick Clark

" I had grown up in Mount Vernon, New York, and had wanted to be in radio since I was 13," Richard Wagstaff Clark, who was born on November 30, 1929, wrote in LIFE. "Rhythm and blues wasn't widely popular yet, never mind rock 'n' roll. I was drawn to big band music vocalists. I dated a girl in high school who liked jazz. Through her, I sort of got in sideways to black music. I loved rhythm and blues." Lucky for us. For when Clark made his way to Philadelphia and his local hit show *Bandstand* went national, the youth of the country were exposed not only to white-bread pop crooners but real rockers of any race, religion or creed. Clark himself could not have been more well-scrubbed, and so parents had a measure of assurance that their kids' daily dose of *American Bandstand* was not life threatening. By late 1958, when this photograph was made on the set, the show was being watched every afternoon by 40 million viewers. The population that year in the United States was 174,881,904, meaning that one in every four or five Americans was watching. Clark, who died in April at age 82, achieved success as well with other music shows, quiz shows and of course his New Year's Eve specials, but *Bandstand* is his legacy. For years America's teenagers—and teenagers at heart—heard the phrase every day: "For now, Dick Clark . . . So long." It really did last so long, which is a good thing. We won't hear it again, which is sad.

When he and Dick Clark died within weeks of each other this year, of course linkages were made: One impresario was responsible for *Bandstand*, the other was the man behind *Soul Train*. Donald Cortez Cornelius was born in 1936 in Chicago's South Side and was a U.S. Marine during the Korean War. After his discharge he worked a series of odd jobs and then as a Chicago cop, but in 1966, with a wife and two kids, he decided to take a flyer and signed up for a broadcasting course. He landed jobs in radio and TV in Chicago, and in 1970 launched *Soul Train* locally as a daily show. Yes: It was a black *Bandstand*. But in showcasing such as Aretha Franklin and Michael Jackson on a more frequent basis, and in spotlighting the exciting dance moves that were constantly evolving, it was different—and when it went national in 1971, it followed the *Bandstand* pattern and became an instant hit.

Cornelius, seen in the photograph opposite in the 1980s, had a far different catchphrase to end his show than Clark's, and it is illustrative of the two programs' differences: "You can bet your last money, it's all gonna be a stone gas, honey! I'm Don Cornelius, and as always in parting, we wish you love, peace and soul!" In the last several years of his life, after a 21-hour brain operation in 1982, Cornelius experienced precious little peace; he suffered a series of seizures, and was said to be in great pain near the end. On February 1, Los Angeles police were called to investigate a shooting at Cornelius's Mulholland Drive home, where they found him dead, at age 75, of an apparently self-inflicted wound to the head.

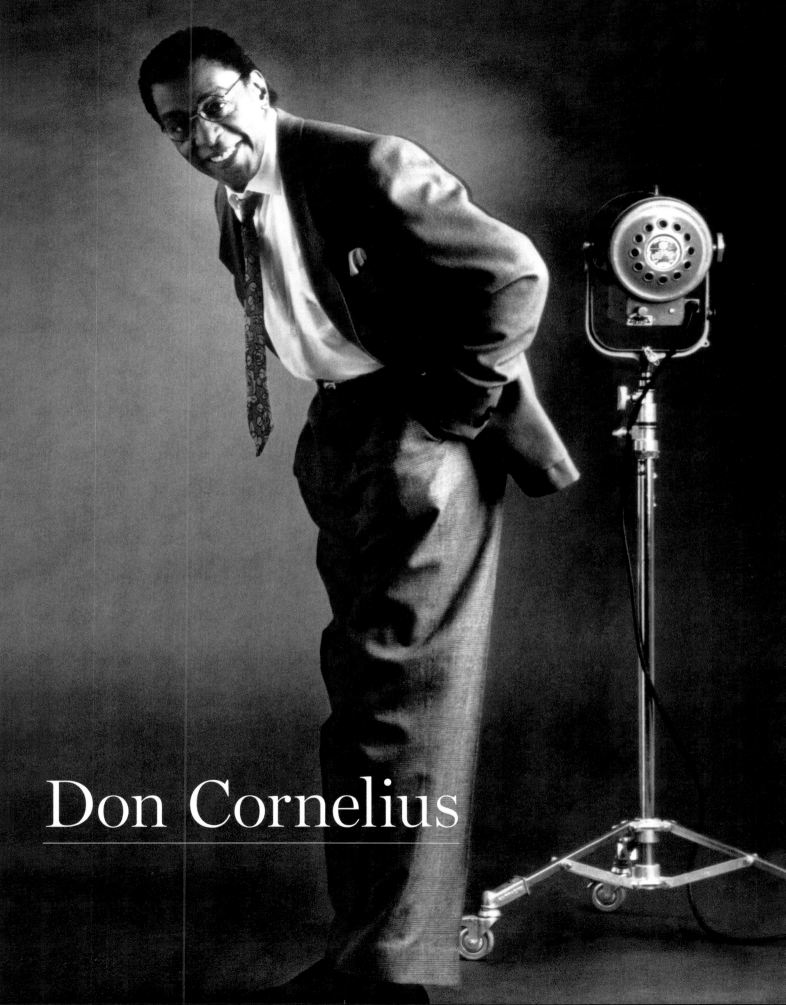

Don Cornelius

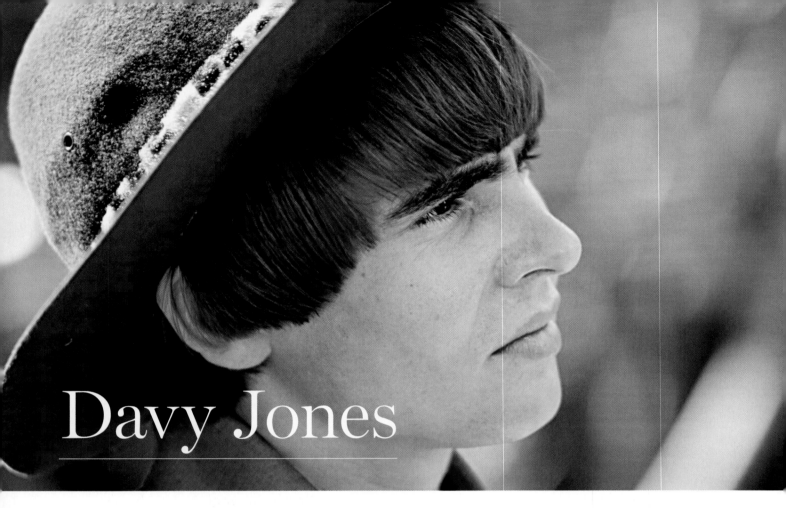

Davy Jones

Rarely do tributes or satires work as brilliantly as the Monkees did. They were supposed to be the Beatles—they knew it, the Beatles knew it, everyone knew it—and their TV show was supposed to be a weekly slice of *A Hard Day's Night*. What couldn't be reckoned was the amount of talent involved: A cocreator of the show was Bob Rafelson, soon to be a cutting-edge film director; early tunes were contributed by such songsmiths as Carole King and Gerry Goffin, Tommy Boyce and Bobby Hart, Neil Diamond; and then there was the perfectly cast fab four: Micky Dolenz, Peter Tork, Michael Nesmith and the wee cute English one, Davy Jones, who died in February at age 66. The television series soared, but lasted only a brief time, from 1966 through 1968. The band, which outsold the Beatles and the Stones in 1967, was a more inexplicable phenomenon than the show. "The Monkees really becoming a band was like the equivalent of Leonard Nimoy really becoming a Vulcan," said Dolenz.

We asked him for his thoughts about his late bandmate and friend, and Dolenz sent these words to LIFE: "David Thomas Jones was born between two worlds—the world of Postwar/Tommy Cooper/Bawdy British Seaside Humor and the world of '60s/Cool/Fab/Gear British Invasion. And he excelled at both. He was the consummate entertainer, often reiterating that whatever the size of the venue or the number of people in the audience, 'It's always the same to me as being in the school play.'

"We, in turn, would often tease him with the old line attributed to Debbie Reynolds: 'The refrigerator light goes on, he does 20 minutes.'

"Considering that he came from working-class Manchester and ended up as such a force in the entertainment industry that another David Jones had to change his name to David Bowie says much for his strength, determination and talent. He was funny, gifted, adorable and very, very streetwise. Above all, he was a devoted and loving family man and father—not an easy task in any walk of life, much less in this crazy business we call 'show.'"

Joe South

When you're a career musician like Joseph Alfred Souter and you live to be 72 years old, you leave behind some material that doesn't quite seem to fit the picture. When Joe South died in September most folks recalled him for having written country-pop classics including "Games People Play" (his own hit for which he won the Song of the Year Grammy in 1970) or "Rose Garden" (a worldwide sensation for Lynn Anderson two years later). But South got started back in 1958 when he sang the immortal "The Purple People Eater Meets the Witch Doctor." He eschewed novelty numbers thereafter, and found able interpreters in Gene Vincent and, a bit later, Billy Joe Royal, who took several South songs, including "Down in the Boondocks," up the charts. South, seen below in the studio in the 1960s, was also a gifted guitarist and can be heard on such recordings as Aretha Franklin's "Chain of Fools" and the Bob Dylan album *Blonde on Blonde*.

Scott McKenzie

The 1960s had room for all sorts: The prefab Monkees, the country-steeped Joe South and, above, the Florida-born Philip Wallach Blondheim who would become famous as Scott McKenzie, singer of the 1967 hippie anthem "San Francisco (Be Sure to Wear Flowers in Your Hair)." As a teenager he had fallen in with, among other musicians, John Phillips, and they teamed in a couple of groups, including, in the early 1960s, the Journeymen, who recorded three albums for Capitol Records before Beatlemania suggested new directions and they disbanded. Phillips went on to found the Mamas & the Papas, while McKenzie, although invited along, set out on his own: "I was trying to see if I could do something by myself. And I didn't think I could take that much pressure." The pressure of stardom would come nonetheless after Phillips wrote and coproduced "San Francisco" for him; the single sold more than 7 million copies. There would be no duplicating that success, and McKenzie dropped out of the business in the late 1960s, only to reemerge in 1986 with a reformed Mamas & the Papas. Two years later, he, Phillips, Terry Melcher and Mike Love co-wrote the Beach Boys' No. 1 single "Kokomo." McKenzie, who suffered from Guillain-Barré syndrome, was 73 when he died in August in L.A.

Levon Helm

Some rock musicians are forced to stray from—or altogether abandon—their roots in order to find success, but that was never the case with Helm, and he and his multitude of fans were the better for it. Call the neighboring genres in which he worked through the years rockabilly, country, roots rock or Americana—call them what you will—Helm played and sang music that was very evidently bred in the bone when Mark Lavon (not Levon) Helm was born to a family of Arkansas farmers in 1940. A multi-instrumentalist best known for his drumming, Helm played in local bands in the 1950s and then fell in with a bunch of Canadian players in support of the rockabilly singer Ronnie Hawkins. The group eventually split from their frontman, but not from one another, and before long they were supporting Bob Dylan as his latest band, soon to be the Band. *Music from Big Pink* and the quintet's eponymous second album are classics, as is *The Basement Tapes*—made up of sessions recorded in Woodstock, New York, both with and without Dylan.

The Band eventually came asunder, not prettily, but Helm had found a home. In Woodstock he became a local treasure, and Levon Helm Studios became a mecca for old-school legends and youngsters who had grown up on "The Night They Drove Old Dixie Down" and "The Weight," as well as new fans (and old regulars) who made the pilgrimage for Helm's raise-the-roof Midnight Rambles. He fought cancer for a long time and recorded wonderful late-in-life, award-winning albums, including *Dirt Farmer* and *Electric Dirt*, before passing away in April, never having traveled very far from home.

Earl Scruggs

In 2012, Scruggs died at age 88. Also in 2012, the British folk-rock band Mumford & Sons were anointed the biggest thing on the musical planet when the first-week sales of their new album trumped those of Justin Bieber. Also, Chris Thile, late of Nickel Creek and now fronting the Punch Brothers, was awarded a so-called "genius grant" from the MacArthur Foundation. Routinely on Mumford & Sons songs, the banjo takes flight, thrillingly, and while Thile does most of his shredding on mandolin, he's also adept at banjo, which is routinely at the fore of his music. Twenty-five-year-old Marcus Mumford and 31-year-old Thile—to say nothing of five-string expert and day-job comedian Steve Martin, who has forged a second or third career with his music—are smart enough to know that they owe a huge debt to North Carolina's Earl Scruggs.

It was Bill Monroe who popularized bluegrass music but Scruggs who revolutionized banjo playing and brought it from the porch into the spotlight. Self-taught, he eschewed the thumb-and-forefinger clawhammer method and saw beauty in the crystalline notes that tumbled forth from nimble three-finger picking. In 1948 he cofounded the Foggy Mountain Boys with guitarist Lester Flatt, and the two men partnered in one outfit or another, most often simply as Flatt & Scruggs, for decades. If the duo is most widely known for its *Beverly Hillbillies* theme, "The Ballad of Jed Clampett," or its breakneck rendition of Scruggs's "Foggy Mountain Breakdown," featured to great effect in the classic film *Bonnie and Clyde*, so be it. Let those tracks be mere introductions, for there is no song on which Scruggs's picking is anything less than remarkable and sublime. It is both poignant and fitting that, in the year he leaves us, the instrument he mastered, revered and reimagined is enjoying its day in the sun.

Kitty Wells

We spoke just now of how Earl Scruggs's banjo legacy extended to and through Mumford & Sons and Chris Thile. Well, Taylor Swift and whoever is the next princess or queen of country music owe a ton to Kitty Wells, a rara avis, a bona fide born-in-Nashville songbird who was the very first (and some would say last) Queen of Country, capital Q. Muriel Ellen Deason was born in the not-yet-nicknamed Music City in 1919. She learned guitar from her dad and sang as one of the Deason Sisters on Nashville radio. She wed at 18 to a local boy, Johnnie Wright, who dreamed of being a music star. (This is starting to sound like a country song.) His hopes were realized as half of Johnnie & Jack (and sometimes as a soloist), and whatever hopes Kitty harbored for herself bloomed into superstardom. (By the way, the two stayed wed for more than 70 years, until Mr. Wright died in 2011.) In 1952, Wells became the first woman to reach No. 1 on the country charts, the song in question being "It Wasn't God Who Made Honky Tonk Angels." Loretta, Dolly, Tammy, Tanya, Reba—and, yes, Taylor—would follow, but Kitty was first. She was 92 when she died in Madison, Tennessee.

Doc Watson

He was blinded by an eye infection at the age of one and he lived 89 years; he passed away in May of this year in Winston-Salem, North Carolina. That wasn't too far from the place in the same state where Arthel Lane Watson had been born: near a hamlet called Deep Gap. He was 11 and had shown a proclivity for music when his father made him a banjo out of the skin of a dead cat. Arthel longed for a guitar—he was an artist instinctively drawn to just the right brushes and palette. This time, his father told him that if he could learn a song in a day, he would somehow find a way to buy him a guitar. Arthel had little problem with his end of the deal, and a week later his dad bought him a $12 Stella. He quickly became known locally as a gifted musician. When he was performing on a local radio broadcast, the host suggested that "Arthel" was unsuitable as a stage name, and a member of the audience suggested, "Call him Doc!"—presumably thinking of Sherlock Holmes's Doctor Watson. The genius flat-picking guitarist, singer and (eventually) songwriter went on from there.

Watson played fast and light, sang deep and resonant, and forged a substantial reputation before he was claimed, and made famous, by the folk-music movement of the early 1960s. He influenced thousands who saw him play and thousands who never did. His own heroes had once been the Carter Family and Jimmie Rodgers, and Watson, whose life reads like an American legend, eventually joined them in the pantheon.

Dietrich Fischer-Dieskau

Since the judgment must be subjective, we can never know who had the most beautiful, expressive voice of the 20th century, but this man would surely be in the discussion. "A born god who has it all," was the assessment of his fellow opera supernova Elisabeth Schwarzkopf. In France he was called "*le miracle* Fischer-Dieskau."

The German lyric baritone, the tall man seen here singing the "Hallelujah Chorus" at Carnegie Hall with violinist Yehudi Menuhin on his right hand and, to his left, cellist Mstislav Rostropovich, pianist Vladimir Horowitz, conductor Leonard Bernstein and violinist Isaac Stern, was an unchallenged master of lieder (art song). He thrilled opera and concert audiences for more than four decades and became perhaps the most recorded singer in classical music history.

Numbers hardly tell the story. If confirmation of his brilliance is required, it should be offered by his peers who shared the stage with him, people such as Schwarzkopf. With that in mind, LIFE approached Plácido Domingo, who is, arguably, today's most highly esteemed living singer of classical music. His tribute follows.

"Dietrich Fischer-Dieskau was without a doubt the most influential singer of German lieder of the 20th century, and probably of any century. He had everything a singer could want: great musical and literary intelligence, an understanding of the background to everything he sang, a strikingly beautiful and powerful voice, the *physique du rôle* and endless curiosity to discover and explore new repertoire. Most important, his interpretations always communicated tremendous conviction.

"The same could be said of his work as an opera singer. Differences in age and repertoire meant that we had few opportunities to meet, but I'll never forget working with him in Eugen Jochum's recording of Wagner's *Die Meistersinger*, in which he was Hans Sachs and I was Walther von Stolzing. I was thrilled, when I was still a young man, to be singing one of the greatest masterpieces in the German opera repertoire with such a great German artist.

"Fischer-Dieskau will be greatly missed, but he will continue to be a presence in the world of musical interpretation thanks to his many wonderful recordings of a tremendous variety of compositions ranging over four centuries of musical creativity."

AP

Vidal Sassoon

S ince Samson's Delilah, there hasn't been a more famous hair stylist. Sassoon bestrode tonsorial terrain like a titan, clipping and snipping and influencing '60s style nearly as much as the Beatles did. Of course, Sassoonistas would claim—and did—that there were miles of distance between a Fab Four moptop and the wedge bob. One could be achieved with a pudding bowl and any old scissors. The other was art.

Sassoon, who died in Los Angeles in May at age 84, was never himself so pompous or pretentious, and perhaps this was due to his heritage. He was born in the East End London slums to Jewish immigrants. His father left the family when Vidal was only three, and he and his younger brother, Ivor, were sent to a Jewish orphanage for seven years. Their mother was allowed to visit them only once a month; when she remarried, she took them home. She sent Vidal to work at a beauty and barber shop when he was 14, telling him he didn't have the brains to pick a trade himself.

A seminal event for Vidal was the 1948 Israeli war for independence, during which he fought for the Haganah, which evolved into the Israel Defense Forces. "The best year of my life," Sassoon later said of his involvement in Israel's successful campaign for statehood. "There were only 600,000 people defending the country against five armies, so everyone had something to do." Back in London, the newly confident war veteran returned to the trade in which he had apprenticed, learning further at Raymond Bessone's salon in Mayfair, then opening his own in 1954. Simplicity and utility were hallmarks of Sassoon's style: "I wanted to eliminate the superfluous and get down to the basic angles of cut and shape."

With calibrated snips, the soon-influential Sassoon banished hair curlers and back-combing for decades, and he galvanized fashion from Carnaby Street to Main Street when he invented the wash-and-wear wedge-cut that, as designer Mary Quant said—referring to her creation— put the top on the miniskirt. Roman Polanski paid him $5,000 to sculpt Mia Farrow's locks for the 1968 film *Rosemary's Baby* (here, Sassoon and Mia at the famous session).

Sassoon revolutionized the salon business as well, on both sides of the Atlantic, meanwhile creating an eponymous line of products, with annual sales topping $100 million when he sold the business in 1983. His slogan for it all was a rare case of truth-in-advertising and reflected his lifelong approach: "If you don't look good, we don't look good."

Nolan Miller

Got bling? Like bling? Like bling on TV? If so, you are a Nolan Miller fan. Miller, who passed away in June at age 79, was the person most responsible for the look of the fabulous 1980s TV series *Dynasty,* as well as other shows. Who better to pay tribute to him than the woman he most famously adorned, Joan Collins. She offered this tribute to LIFE: "Nolan was the most caring, kind and wonderful friend, not to mention a fabulous designer. I called him my other brother, and his death this year left me shattered.

"I first met Nolan in the wardrobe department at 20th Century Fox when I was cast in *Dynasty.* Exceedingly tall, elegantly dressed and extremely handsome, Nolan was the epitome of old-world charm. He was a true gentleman in an age when that creature rarely existed anymore. He had already been a top fashion designer for movies and television and had dressed amongst others Joan Crawford, Lana Turner and Barbara Stanwyck. He particularly adored Barbara Stanwyck, who was one of his closest friends, and he admired her tremendously. He had a wealth of outrageously funny anecdotes about all the other actresses he had clothed, but Barbara Stanwyck was special.

"His story of how Phyllis Diller [please see page 124] had stripped off in front of him and the entire wardrobe department had me in stitches. During the '80s he designed dresses for *The Love Boat, Fantasy Island* and *Charlie's Angels,* but he admitted that making couture gowns for Linda Evans, Diahann Carroll and me on *Dynasty* was his favorite work.

"We became great pals during *Dynasty,* where in the end the wardrobe budget was in excess of $30,000 per week, and we became even closer after the show ended. When limited edition Krystle and Alexis dolls were released, Nolan designed the extravagant frocks the dolls were wearing. I continued visiting his atelier in West Hollywood, since nobody else was able to produce such exquisite and flattering gowns. I still treasure some of my beautiful dresses with the Nolan Miller label in them.

"It was at Christmas 2006, when he was staying with me and my husband, Percy Gibson, and a group of friends in a house we'd rented in Acapulco, that we had heard him coughing all night and I told him he should see a doctor. Sadly, it was a foretaste of the serious illness that finally took his life six years later.

"Nolan never said a bad word against anyone, even though there were those who tried to destroy him, but with his acerbic wit, charm and easygoing personality, he was able to surmount the viciousness. It is as the best, most loyal and incredible friend that I shall always remember Nolan Miller."

DAVID TSAY/CORBIS

Charla Krupp

er advice to women on how to remain (or appear) younger and better, expressed in the best-selling books *How Not to Look Old* and *How to Never Look Fat Again*, made her a kind of guru, even a hero. Charla Krupp , who earlier in her career was an editor at *Glamour* and *InStyle*, died at age 58 in New York City of breast cancer, and her longtime friend Katie Couric offered this tribute to LIFE: "I first met Charla when I had just come to New York in 1991 to coanchor the *Today* show. She wrote one of the first articles about me in *Glamour* magazine and turned my tendency to be a 'Glamour Don't' into an asset with the headline: 'Score One for Real Women.' More importantly, she became my friend. Charla was an incredible friend—generous, kind and thoughtful. I still think of her looking at me with those huge, expressive honey-colored eyes and beatific smile . . . curious, caring, loving and warm.

"During the early years of our friendship, Charla and I became a staple on the *Today* show. We were on together 113 times . . . and we had so much fun! How could you not, given Charla's unbridled enthusiasm about everything from bath gel that smelled like grape jelly to throwing the prettiest, preppiest tailgate party, complete with football-shaped brownies . . . to control-top thongs.

"Charla was no dumb blonde. Sure she was a girly girl, but she was tough, practical and did not suffer fools gladly. I loved that so much about her. She was focused and directed, an unapologetic feminist who didn't take any guff from anyone. And she had no patience for users, climbers and hangers-on. She was always so excited about the next *Today* show appearance, the next book, the next stop on her career, the next big thing that was just around the corner.

"She was so engaged in everything you said, and gave you her undivided attention, and made you feel so special. That's one of the many things that made Charla special. She made you feel as if she were basking in your aura, when the truth is: You were basking in hers."

WWD/CONDÉ NAST/CORBIS

DPA/ABACAUSA/POLAR

Seen here working on a model of the Type 911, the sloped-roof sports car that caused auto enthusiasts to drool unbecomingly after its introduction in 1963, Ferdinand Alexander Porsche was known at the Porsche company as F.A. This was certainly in part because there was an original, even more legendary Ferdinand Porsche: his grandfather, who was also a genius designer and who founded the German firm after making his legend in Volkswagens and Mercedes-Benzes. That pioneering Porsche is historically controversial due to his affiliation with the Nazis and also his enforcement of working conditions at Volkswagen that were said to be tantamount to serfdom if not slavery. Not so with F.A. He was a craftsman: The form and function of a machine is what interested him. (In fact, he gave over the day-to-day running of Porsche to his relatives in the 1970s.) He drew many wonderful things, including eyeglasses, watches and pens, as well as cars, but the 911 remains his "Mona Lisa." Manny Alban, president of the Porsche Club of America, has likened the classicism of the car's design to that of the Coke bottle, and said that the "Porsche Carrera S" on today's models is not superfluous as much as misleading: "A lot of people would say you don't need that because a Porsche enthusiast would say you can look at it and know it's a 911." F.A.'s modus operandi—"a formally coherent product needs no decoration, it should be elevated through pure form"—informs every inch of the 911. This second renowned Ferdinand Porsche was 76 when he died in April in Salzburg, Austria.

Ferdinand Porsche

Sylvia Woods

THOMAS HOEPKER/MAGNUM

As a child in the 1930s, Sylvia Pressley worked the fields in Hemingway, South Carolina, where over bean plants she met Herbert Deward Woods. She was only 11 and he was 12, so despite love at first sight, this relationship was put on hold. As teenagers, they were allowed to court, but only on Wednesday and Sunday evenings. More impediments arose: When Sylvia's mother persuaded her to move to New York City to become a beautician, Herbert joined the Navy and landed across the country in San Francisco. But love would find a way, and did. After they finally married in 1944, they settled in Harlem and spent holidays in Hemingway. Sylvia later said that she always thought of Hemingway as a suburb, and that a secret advantage of her immersion in her hometown was that it had more good cooks than a cooking school, and she was learning just by being there.

She had rarely eaten out when, in the mid-1950s, she took her first job at a Harlem luncheonette within walking distance of her apartment. Eight years later, her mother mortgaged the family farm, and Sylvia and Herbert bought the place and rechristened it Sylvia's Restaurant. It could seat 35 people then; it can seat more than 450 today. Sylvia's home cooking quickly became locally famous; over time, the word spread citywide, regionally, nationally and then even internationally. Busloads of Japanese and Korean vacationers would unload on Lenox Avenue near 126th Street, and the happy and hungry tourists would troop into Sylvia's to enjoy Southern staples like fried chicken, ribs and collard greens. Though not on the restaurant's menu, "our whole family's favorite dish of my grandmother's was rice perlo, a version of paella from our region," recalled Sylvia's grandaughter Tren'Ness Woods-Black. Over the years Robert F. Kennedy, Muhammad Ali and Bill Clinton became regulars, and presidential candidates such as Barack Obama thought it providential to lunch with the Queen of Soul Food (seen here in 1986). Folks who never visited New York could share in the experience through cookbooks and a line of prepared foods. She was 86 when she died at her home in Mount Vernon, New York, in July.

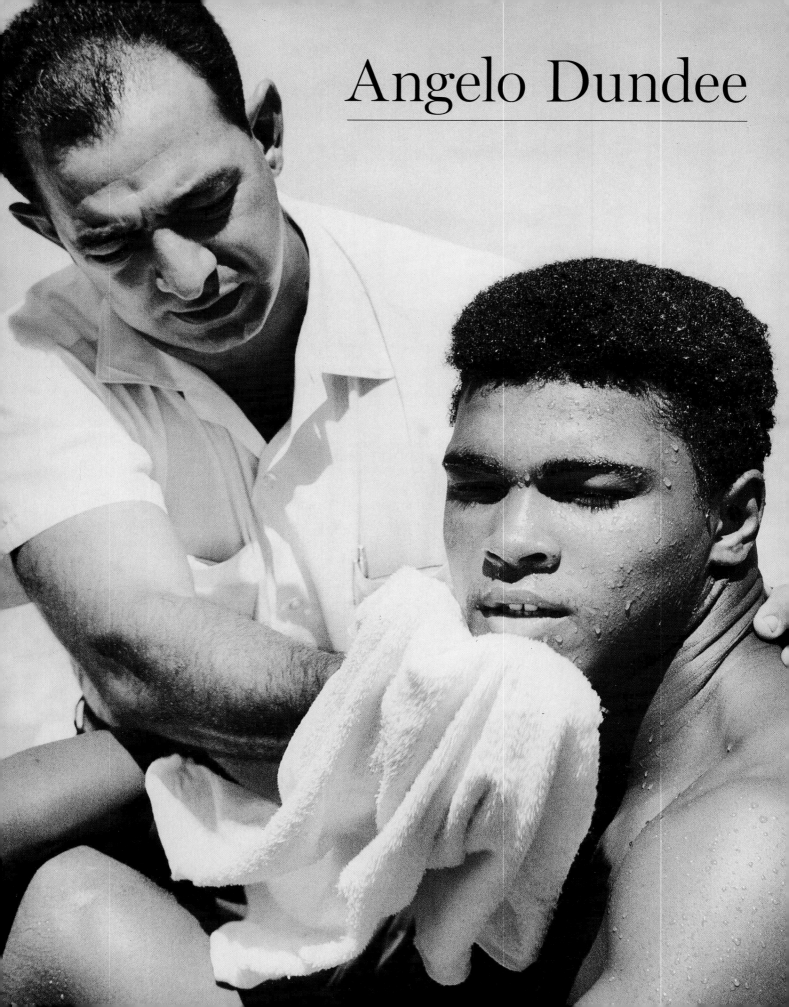

Angelo Dundee

Born Angelo Mirena in Philadelphia in 1921, he first learned the sweet science during his Air Force days in World War II, and later in the gyms of New York and Miami, apprenticing to earlier great boxing trainers—Ray Arcel, Chickie Ferrara—before building his own legend. Certainly Dundee's legacy rests primarily on his association with Cassius Clay (here, training in 1961), a young Olympic champion boxer who would become known to history as Muhammad Ali. Dundee and Ali were a team for much of the 1960s and '70s, but Dundee world champions also included George Foreman, Jimmy Ellis, Carmen Basilio—and Sugar Ray Leonard. LIFE asked Leonard to remember his late mentor, and he sent this tribute:

"Angelo Dundee the man to me was even greater than the trainer. He was the guy I could talk to. There was a world of things beyond boxing, things about presentation. He made sure I was in shape and that I was relaxed. He'd say 'If you move to the left, the sucker'—he always called the opponent 'sucker'—'will end up being punched.' I learn things visually, and we would create visuals.

"People ask me if I miss boxing. I miss Angelo. He was something of a father figure, and he was a hard worker, a good man, a smart man. We hung out. My first wife and I made trips with him. We'd visit him in Florida, we'd go fishing, so we bonded that way. When business issues flared, it never got personal. His best advice was 'Treat your wife well.' Helen, his wife, was all about Angie. She supported him but she didn't let him get away with anything.

"I saw him two weeks before his passing. His son told me he was going to be 90 and there was a party in Chicago. I arranged to be there. We hugged and sat at the table just talking. When his son called two weeks later to say, 'Pop's gone,' I just lost it."

Teófilo Stevenson

Louis, Dempsey, Marciano, Ali, Foreman, the Sugar Rays: We remember the greatest-ever boxers. Teófilo Stevenson Lawrence was one of them, but many Americans need a reminder as to who he was. Why is that? Because he was from Cuba, and arrived at his considerable and long-lived powers well after the Cuban Revolution had installed Castro and his brand of communism, which made Cuba, a great sporting nation among other things, an isolated state. Stevenson's choices were two: Stay as a national hero, boxing the occasional worthy Soviet champion and emerging onto the world stage every four years at the Olympics. Or attempt a desperate defection, with the fame and fortune available in America as a potential reward. Stevenson, seen here in Havana in 1992, stayed, and became known as Cuba's greatest-ever boxer and, perhaps, its most revered contemporary figure—Castro included in the discussion.

Stevenson's father, also named Teófilo, was a broadly built immigrant from Saint Vincent who was encouraged to try a little boxing by local trainers in Cuba. His boy hung out at the open-air gym and eventually laced up the gloves. When his mother found out she was horrified, but finally let the matter rest if Teófilo senior would monitor junior's progress and safety. They might have been more concerned about the safety of young Teófilo's opponents.

The government-run boxing council oversaw the sport, which was strictly amateur, and at its derelict facilities in Havana, Stevenson emerged. He won the first of his three Olympic gold medals in in 1972, ending America's recent dominance of the heavyweight class. He was 60 when he died in Havana in June.

One of the most inspiring football stories of recent decades turned into one of the saddest, most tragic stories of 2011 and 2012—involving child abuse and misplaced trust. When Joseph Vincent Paterno succumbed to complications of lung cancer at age 85 in January, the saga was punctuated by death.

JoePa, it was long said, did things differently: He did them the right way. As a coach, the former Brown University quarterback maintained that he wanted his football players to get an education. He kept his eye on graduation rates at his operation at Penn State as it grew from a mid-level program into a powerhouse. He was there a long, long time: He began as an assistant coach in 1950 and assumed the top job in 1966. He enjoyed unbeaten seasons in 1968 and '69, then another in 1973, and won national championships in 1982 and '86. He was named *Sports Illustrated*'s Sportsman of the Year. He turned back numerous overtures to coach in the National Football League, saying college was what mattered to him. It was often said he had become a beloved "institution" on the State College campus. Unimpeachable. Unassailable.

In November 2011, Penn State fired him. Paterno's longtime assistant coach Jerry Sandusky had been caught up in a sex abuse scandal. (In 2012 Sandusky was convicted on 45 of 48 abuse charges and sentenced to 30 to 60 years in prison; he is appealing the conviction.) The university's board of trustees had determined that the coach had not been proactive in dealing with allegations of Sandusky's sexual interactions with young boys, a conclusion confirmed in July 2012 by an independent investigation conducted by former FBI director Louis Freeh. The Paterno statue hard by the football field in State College was removed.

VINCENT LAFORET/THE NEW YORK TIMES/REDUX

Joe Paterno

Johnny Pesky

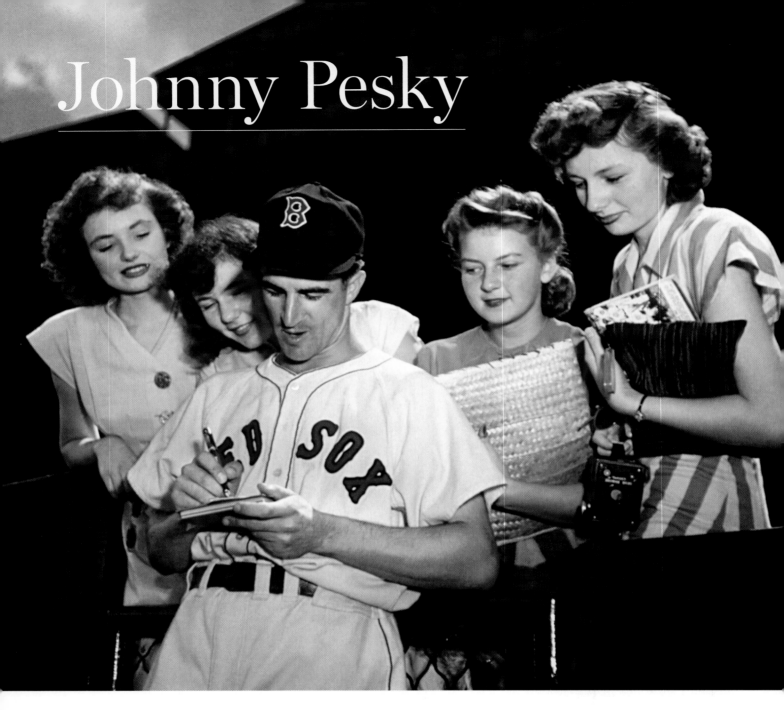

It is fitting that as we visit the sport of baseball, a subtheme becomes nicknames. For his part, John Michael Pesky—born Paveskovich to Croat immigrants in Portland, Oregon, in 1919—could have simply stuck with "Pesky," for he certainly was that, a tough strikeout for any pitcher. But in fact he was called "the Needle" during his playing days and "Mr. Red Sox" in recent years. He also loaned his own name to the major leagues' most famous foul pole.

An infielder for three teams from 1946 through 1954—like his Red Sox teammate and close friend Ted Williams, he lost time while serving during World War II—he would ultimately spend 73 years in baseball as a player, coach, manager and ambassador, 61 of them with his beloved Sox. He could hit, but had little pop—only 17 career home runs, six of them at quirky Fenway Park (where he is seen signing for fans during his rookie year). The right-field foul pole in Boston is barely 300 feet from home plate, and the legend is that Pesky made a habit of wrapping line drives around the pole for cheap homers. Although the story is apocryphal, the so-called Pesky Pole will be a suitable tribute to a Fenway favorite forevermore.

Moose Skowron

The native Chicagoan William Joseph Skowron Jr., who was 81 when he died this year, was a big guy with a big bat, but that's not why he was called "Moose." In the late 1930s his grandfather gave the lad an unfortunate haircut, and his friends thought they saw a resemblance to a fascist dictator who had been appearing in the newspapers. They started calling him "Mussolini," which, thank goodness, was quickly shortened to "Moose." When he starred in football and basketball at Weber High and then football and baseball at Purdue—he hit a Big Ten record .500 his sophomore year in college—the name he brought with him seemed only too apt. The New York Yankees signed him, and by the second half of the 1950s he was their star first baseman; as a Yank he played in seven all-star games and was a hero of the 1958 World Series.

Gary Carter

In a game where lots of men are really just big kids, Carter's fans and colleagues singled him out as "Kid." Gary Edmund Carter earned the nickname with his exuberance and love of the game, and kept the moniker his entire 19-season career, which was spent most notably with the Montreal Expos and the New York Mets, whom he helped lead to a dramatic seven-game World Series win over the Boston Red Sox in 1986. Carter was one of the finest catchers ever to don the mask. An 11-time all-star and a Hall of Famer, he had a gun for an arm and could hit with power. He recently battled cancer, and was only 57 years old when he died in West Palm Beach, Florida, in February.

Jack Twyman

As a basketball player, he was great; as a humanitarian, he was better than that. John Kennedy Twyman starred as a forward at the University of Cincinnati and then in the NBA for the Royals, where in the 1959–60 season he and Wilt Chamberlain became the first two ever to average more than 30 points per game. He played in six all-star contests and is in the Hall of Fame. But he will always be remembered for the selflessness he exhibited after the final game of the 1958 season, in which his teammate Maurice Stokes suffered a head injury. When his friend was left paralyzed, Twyman—only 23 years old—became Stokes's legal guardian. (The two are seen outside Cincinnati's Christ Hospital in January 1960.) Twyman helped Stokes to learn to communicate by blinking his eyes, and remained his brother's keeper until Stokes died in 1970. "Anybody would have done the same thing," Twyman told *Sports Illustrated*. Not true, of course. He was 78 when he died in Cincinnati.

Don Carter

Any sport does well to have the superstar come along who catches the public's fancy and draws armies of fans to the arenas and stadiums, makes them want to head themselves to the gym or the fields or the courts or the links or, in this case, the lanes. Baseball had the Babe, football had Johnny Unitas and Joe Namath, basketball had Magic and Larry and Michael, golf had Arnie, tennis had Chrissie and Jimmy, and bowling had, in the 1950s and early '60s, Donald James Carter, a native of St. Louis who had worked in his boyhood as a pinsetter and learned to roll the ball like no one else. (For one thing, he always kept his elbow bent, as can be seen in this 1955 photograph, whereas most of the top-flight bowlers kept the delivery arm straight.)

A transcendental star can put a sport on the map, and Carter's story well illustrates how he did that for bowling. After a tour of duty on a Navy tank carrier in the Pacific during World War II, he returned home and, having been a talented ballplayer in high school, gave baseball a try, playing a single season for one of the Philadelphia Athletics' minor league teams. Then it was back home, where he worked at the Golden Eagle Lanes in St. Louis as a jack of several trades—bartender, janitor, ball-return fixer— while perfecting his form during down time.

Even for one as talented as he was, the road to fame and riches in what was largely seen as a nice family recreation wasn't clear. He gained a measure of national notoriety as a member of the Budweiser bowling team, based in St. Louis. Before the establishment of the Professional Bowlers Association in 1958, of which Carter was a founding member, the "pro tour" was a loosely defined concept, but it was evident that Carter was the best there was, and he won Bowler of the Year titles in 1953, '54 and '57, then again in '58, '60 and '62. As bowling boomed, thanks to the increased TV exposure of Carter and his competitors, it was fitting that "Mr. Bowling" got his cut. In 1964 he signed the biggest endorsement contract ever by an athlete in *any* sport—a cool million dollars to boost the Ebonite line of bowling products.

Don Carter was 85 when he died in January.

Alex Webster

It was an earlier era. Frank Gifford, the New York Giant great who was a teammate of Webster's in the 1950s and '60s, remembered to *The Palm Beach Post* in 2008: "He was always amazing to me. He smoked and drank, not to excess, and then he'd come out and play a whole game and run over people. He was one tough dude." That toughness granted him 80 years of life before he died in Florida, and also helped lead the Giants to six division titles and an NFL championship, while the bruising six-foot-three, 230-pound running back gained 4,638 yards and scored 39 touchdowns in 10 seasons (seen at left in 1956). Webster later coached the team, but that tenure is not what the fans remember of "Big Red." They remember what Gifford remembered in his memoirs: "People either bounced off him or he ran over them. Every time he got the ball, he turned into a grinding machine."

MARVIN E. NEWMAN/SPORTS ILLUSTRATED/GETTY

Alex Karras

As was the case when playing against Webster, you really didn't want to be in Alex Karras's path. As a four-time Pro Bowl selection as defensive tackle for the Detroit Lions in the 1960s, the six-foot-two, 250-pound "Mad Duck" was a fierce presence on the field. Off of it, he was funny, engaging and whip smart, which led to careers in broadcasting, film and television. On the big screen, he had memorable turns in the Mel Brooks comedy *Blazing Saddles* and the Blake Edwards musical comedy *Victor, Victoria*. He is best remembered by television audiences for the sitcom *Webster*. If there seemed to be chemistry between him and his costar Susan Clark, there was. They had met while filming the TV movie *Babe*, in which Clark played the athlete Babe Didrikson Zaharias and Karras portrayed pro wrestler George Zaharias, and wed in 1980. They remained married until Karras's death in October at age 77.

VERNON BIEVER/GETTY

HARRY HIRSCH/BETTMANN/CORBIS

Steve Van Buren

A native of Honduras who had been orphaned as a child and raised by relatives in New Orleans, Van Buren (seen above in 1947) was noticed by coaches at Louisiana State University and went on to become one of the best running backs in history. His career statistics with the NFL's Philadelphia Eagles tell some of the tale, but two particular games tell more. In 1948 the Eagles were to play the Chicago Cardinals for the NFL championship when a raging blizzard swept in. Van Buren thought the game would be canceled, but then decided to go just in case. After rides on a trolley, a bus and a subway, followed by a seven-block trudge through knee-deep snow, he arrived at Shibe Park, where he scored the day's only touchdown and led the Eagles to their first title. A year later, in a driving rain in L.A. Memorial Coliseum, he ran for 196 yards as the Eagles beat the Rams for a second crown. Van Buren was 91 when he died in Pennsylvania.

COURTESY THE UNFORGETTABLE BUZZ

Norman Sas

From left, we see here, in 1971, Norman Anders Sas, NFL Commissioner Pete Rozelle and John Waddle of Sears. The object of their affection is a Suped-up version of Electric Football, the tabletop game invented by M.I.T. grad Sas back in 1948 that had soared in popularity after Sas signed a partnership deal with NFL Properties in 1967. Sas, impressed by a vibrating horse-racing toy he had seen, figured shakin' and quakin' football players would be even more exciting: Line up your players, put the ball in the QB's hand, flip a switch and watch as the energized metal field caused mayhem—players skittering every which way. For about a decade, Electric Football was a winner, "then the [video] games came out," Sas lamented to *The Washington Post* in 1999, "and that was the beginning of the end." Norman Sas was 87 when he died in June in Florida.

Sarah Burke

Few things in life afford as much joy as athletic activity. Of course, in attempting to go faster or higher, or to become stronger, there are risks—but the elite athlete, knowing how fine it is to soar or sprint or simply succeed, willingly assumes those risks. Sometimes, we who watch, living vicariously through our champions, find ourselves sharing in the sadness of tragedy as if these people had been our friends, even our family. So it was when the Canadian freestyle skier Sarah Burke, a world champion and four-time Winter X Games gold medalist who would have been a favorite when half-pipe debuts at the Olympic Games in 2014, died after an on-course accident in Park City, Utah, in January. Burke, seen here in 2000 flipping and twisting as she launches off a ramp carved into a glacier's cornice in British Columbia, Canada, was 29 years old.

GEORGE SILK

Jill Kinmont

More than a half century ago, this skier, too, suffered a terrible fall. During a giant slalom race at the Snow Cup in Alta, Utah, in January 1955, 18-year-old Kinmont crashed, was nearly killed and was left paralyzed from the shoulders down. If you think you know this story—the energetic teenager from Bishop, California, who had already won a national championship and was a hopeful in the next year's Olympics, a *Sports Illustrated* cover subject now forced to reimagine and reinvent her life—you do: It was told in two 1970s movies, *The Other Side of the Mountain* and its sequel. Jill Kinmont Boothe fought her way back and then gave back to society with her 32-year career as a teacher in an elementary school, mainly in her hometown, where she died at age 75.

MATT A. BROWN/ICON SMI/CORBIS

Junior Seau

His death at age 43 by suicide—a gunshot wound to the chest—was one of those stories that left not only football fans but also any who had encountered Seau or seen him play, however briefly, bewildered. In his lengthy and brilliant career as a star linebacker—a sports god in San Diego (seen below in 2002), a solid team player for Miami and then New England—he brought fun to big-time football (if not to opposing quarterbacks). Big, good-looking, fast, athletic (he also starred in basketball and track and field in high school, and by the way had a 3.6 grade-point average), passionate, always with a happy smile, Tiaina Baul Seau Jr., a San Diego native of Samoan descent, had it all. Or so it seemed.

He retired from pro football after 20 seasons in 2010 and moved back full-time to California. He said he was excited about the next stage: building his foundation to help children in harm's way; working on his restaurant in Mission Valley, which had opened in 1996; hanging out with his four kids; engaging in community work with the Samoan "sister city" program in San Diego County; doing some surfing. But in the aftermath of his death, it has emerged that those closest to him knew there were problems. In October 2010 he plunged his SUV down a cliff not long after he and his girlfriend had had an altercation and he had been arrested for domestic violence (though he was never formally charged). He said he had fallen asleep at the wheel, but there has always been suspicion that this was a first suicide attempt. When Seau did in fact kill himself, many wondered if the recent hot issue of concussions in football might apply: Had concussions led to his depression? But an autopsy showed no significant damage to the brain. Why did Junior Seau take his own life? The question bewilders still.

Television being such a powerful medium, and the iterations of Andy Griffith's Mayberry shows and then *Matlock* being so popular, much about the earlier career of this major star goes forgotten. A native of Mount Airy, North Carolina, who slept in a dresser drawer as an infant because his parents were so poor and who died 86 years later on the eve of the Fourth of July, Griffith was the embodiment of an American story, yes, but he was not just Sheriff Andy Taylor. He started as a comedian and had a Top 10 record with his monologue "What It Was, Was Football." He came to national prominence with his amiable performance in the teleplay *No Time for Sergeants*, and then played dark—very dark—in the 1957 Elia Kazan movie *A Face in the Crowd*. He was nominated for two Tony Awards for his stage acting and won a Grammy for his gospel singing. He was awarded the Presidential Medal of Freedom.

His friend and mentee Ron Howard (the two are seen here on the set of *The Andy Griffith Show* in the early 1960s) remembered Griffith for LIFE: "I have had a lot of good fortune in my life both personally and professionally. One of the real blessings was being on *The Andy Griffith Show* as a child actor. There was something so calm and yet so charged with creation that it was the perfect experience of what a life in this medium could be like.

"As I grew older and spent more time on sets, it kept coming back to Andy—how he created, how he dealt with people. It was so honest and so personal to him that he created a remarkable space where the work got done. He was intense and complex. He could be upset about things. He could find things funny. He could be a serious problem solver. He could be playful and gentle. I would never consider him to be mercurial, though. He was grounded in an honest response to the environment.

"He was really in touch with the truth of things. The shows he was involved with all reflected a kind of wisdom and were bound up with all the strengths and ways things functioned. That's why he had an enduring career. As is true with a great artist, his work was a reflection of his point of view.

"His early monologues on football are witty and not just cornpone or sketch comedy about rural America. There was a point of view. Whatever he touched, especially what he cared most about, had an interesting through line. He wove it through stand-up, music, comedic arts in three mediums, and stage and drama. I submit that it is a through line that I respect."

Andy Griffith

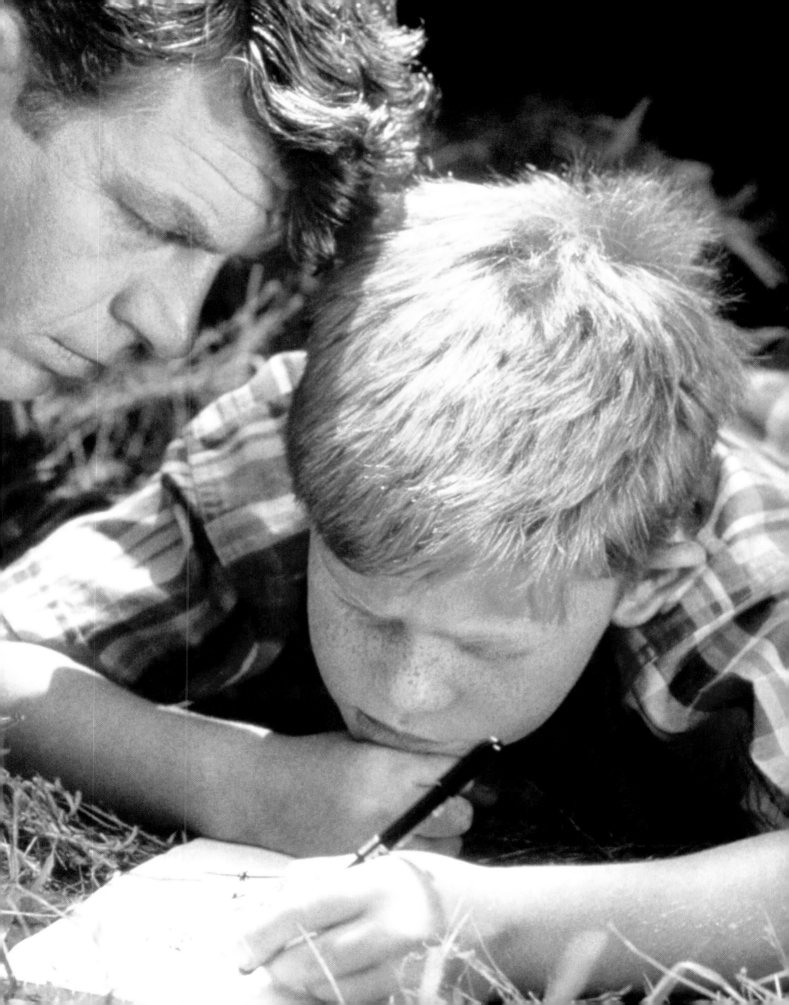

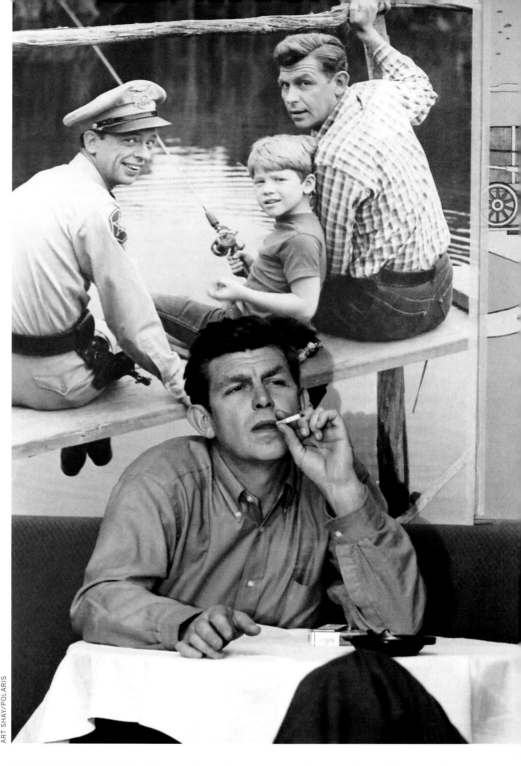

GRIFFITH SAID that his audience had a skewed impression of him, and these photographs illustrate the point. At left, in November 1956, he is on the set of *A Face in the Crowd* with director Kazan. This scathing look at celebrity and politics in America was written by Budd Schulberg, and after it came out you might've bet Griffith was poised to be a Robert Ryan or Rod Steiger— or even Brando—type of actor, rather than Andy of Mayberry. Above: In November 1961, the star is on a train in Nashville during a tour of the South. *The Andy Griffith Show* had debuted the year before and would last until 1968. In the hearts and minds of Americans, God bless them, Andy Griffith's image was set in stone. (As you know, with him in the background are Don Knotts as Deputy Sheriff Barney Fife and Ron Howard as Opie Taylor.)

Ernest Borgnine

The high points of his career were not unlike those of Andy Griffith's: He gained respect and renown for serious cinema made in the mid-1950s. In fact, he won the Best Actor Oscar. But he became most widely known (and beloved) for a starring role in a popular 1960s sitcom. He kept working nearly till the end of his 95 years; he was nominated for an Emmy for a guest role on *ER* when he was 92. He was the voice of Mermaidman on *SpongeBob SquarePants* from 1999 to 2011, and it is fair to say that Borgnine, in his time, entertained four or five or even six generations of Americans— a rare feat. Because his contributions live on in celluloid, he will entertain many more.

Ermes Effron Borgnino was born in Connecticut to Italian immigrants in 1917, and after high school enlisted in the Navy. He had finished a six-year stint when Pearl Harbor was bombed. Back in he went, for the war's duration, eventually accruing several service decorations, plus memories for use down the road in *McHale's Navy.*

Borgnine later remembered: "After World War II we wanted no more part in war. I didn't even want to be a Boy Scout. I went home and said that I was through with the Navy and so now, what do we do? So I went home to mother, and after a few weeks of patting on the back and, 'You did good,' and everything else, one day she said, 'Well?' like mothers do. Which meant, 'Alright, you gonna get a job or what?'" Mom had a suggestion: "She said, 'You always like getting in front of people and making a fool of yourself, why don't you give it a try?' I was sitting at the kitchen table and I saw this light. No kidding. It sounds crazy. And 10 years later, I had Grace Kelly handing me an Academy Award." That was for *Marty,* in which the always-unlikely lead played a warmhearted butcher; it must be noted that the other Oscar finalists were named Sinatra, Dean, Tracy and Cagney. The aforementioned *McHale's Navy* was the popular sitcom, running from 1962 to 1966, and Borgnine joined other '50s film stars, including Griffith, Fred MacMurray and Buddy Ebsen, in, quite justifiably, cashing in. The best news: Borgnine was at home in a Navy uniform, and was happy to serve the rest of his long life as an icon for other veterans.

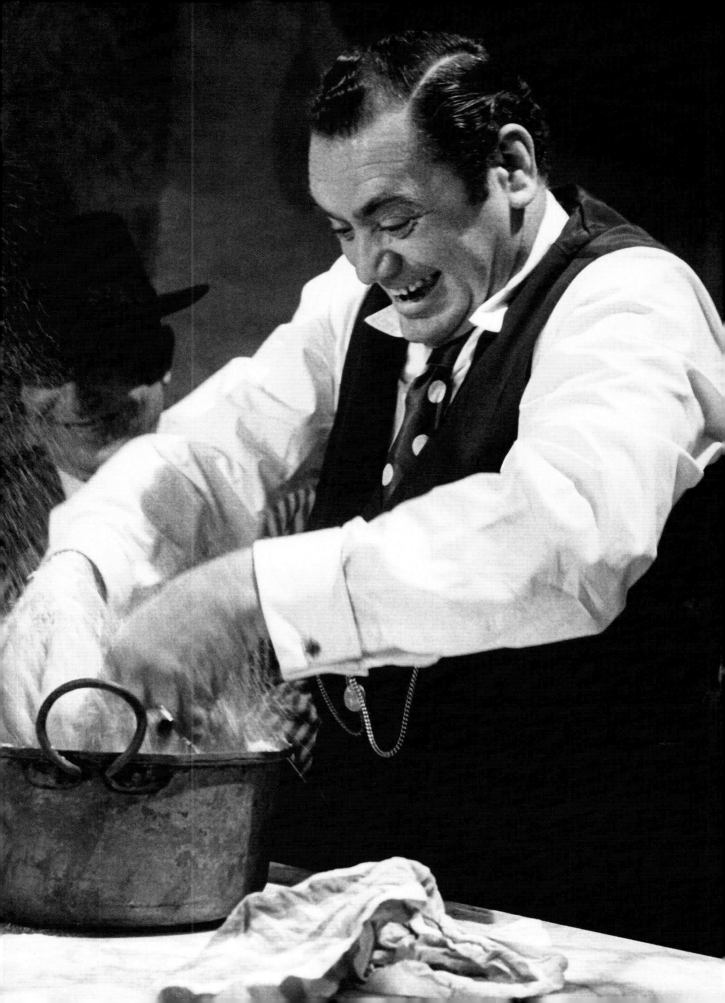

She too, like Ernest Borgnine, was 95 when she died. Like Borgnine and Andy Griffith, she was known to film fans for one thing, to TV audiences for something quite other. Like Griffith, she could sing. Like Borgnine, she won an Academy Award. Like Griffith when he played "serious" or Borgnine when he assayed a romantic lead, she overcame preconceptions. She proved herself, time and time again.

A native New Yorker, Celeste Holm had a peripatetic upbringing, finally landing in Chicago, and along the way grew interested in stage acting, which she studied at the University of Chicago. When she tried out for the role of the amorous Ado Annie in the original 1943 production of *Oklahoma!*, composer Richard Rodgers thought she was too polished. Holm quickly performed a startling hog call, won the part and established herself as a Broadway musical star. Next was Hollywood, where she faced resistance when applying for dramatic roles. But she landed some, and won the Oscar for Best Supporting Actress in the classic 1947 commentary on anti-Semitism, *Gentleman's Agreement*. She was also nominated for Academy Awards for *Come to the Stable* and *All About Eve*. An aside: Holm had lots of firends in Hollywood, but on *Eve*, she did not get along with star Bette Davis, who at one point retorted with an uncivil "Oh, [expletive]! Good manners!" in reply to Holm's simple "Good morning.")

The actress was introduced to even wider audiences by TV's popular nighttime soap *Falcon Crest* and the daytime *Loving*. Like Borgnine, she worked throughout, and her final two films are in prerelease. Like Borgnine, she married five times (her last husband was less than half her age). Like Borgnine and Griffith, she tried everything, many media, and used all her talents, which brings us to this photograph. It was taken by LIFE's storied staffer Alfred Eisenstaedt (he of the "Sailor Kissing the Nurse" photo), who was trusted implicitly by the kings and queens of Hollywood. Holm is receiving a massage between nightclub performances in 1951. Whether it was Eisie or Celeste who suggested the final placement of the sheet is lost to history.

ALFRED EISENSTAEDT

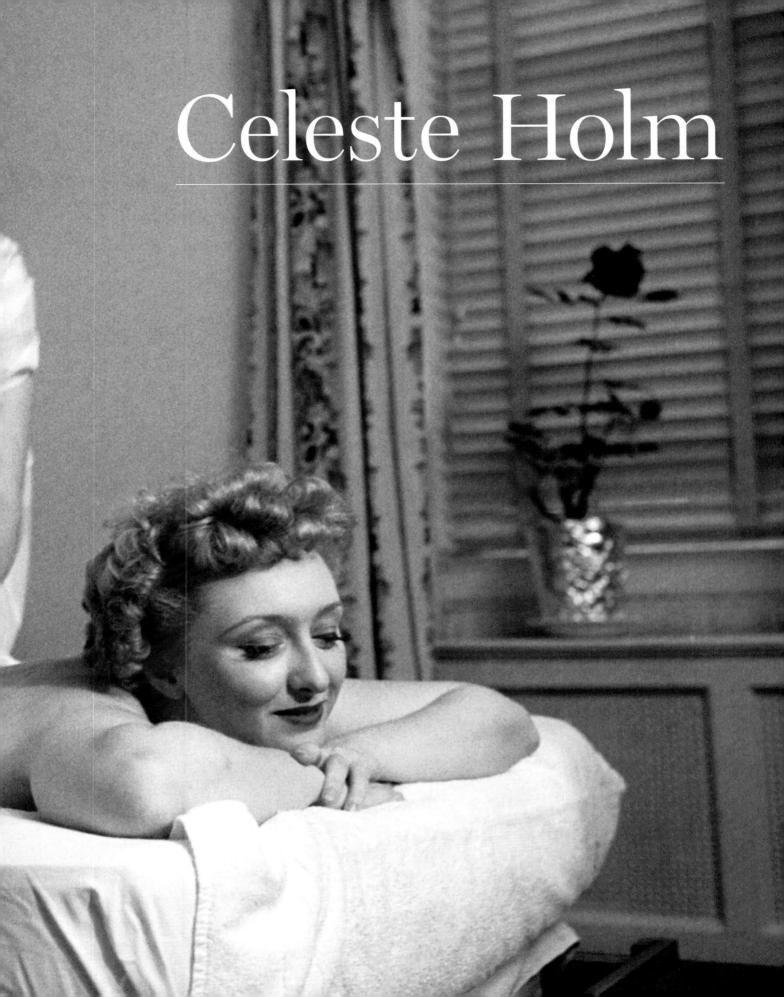

Celeste Holm

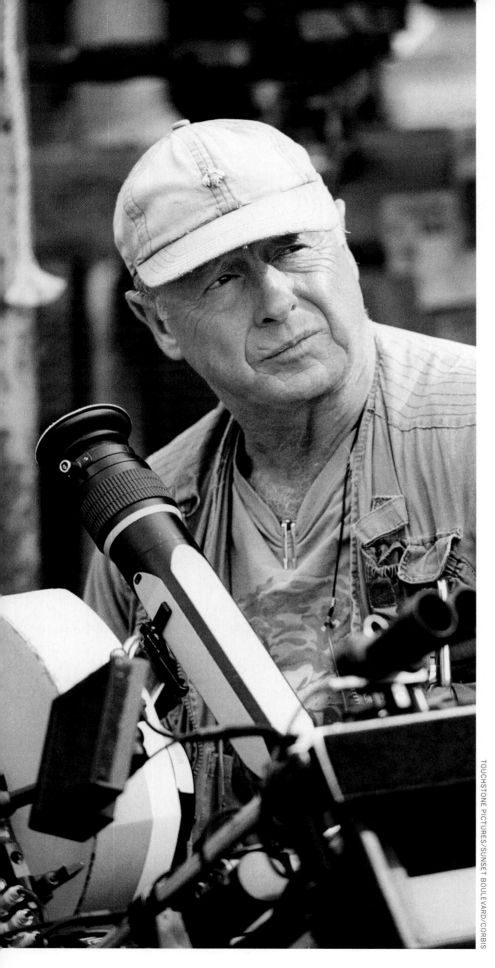

Tony Scott

S uicide is often hard to explain, and some people consider it almost always indefensible. They ask: What made Junior Seau feel that he had to drastically take his own life? With so much going for him, mightn't he have seen a light at the end of the tunnel if he had sought help? Similarly, none of Tony Scott's friends saw it coming: that, in August at age 68, he would jump from the Vincent Thomas Bridge in Los Angeles.

Anthony David Scott was born in England but with what we now know of his aesthetic sense as a film director, he was destined for Hollywood. Once he had followed in the footsteps of his older brother, director Ridley Scott, and landed there, he found a producer–soul mate: "Jerry Bruckheimer was very bored of the way American movies were very traditional and classically done. Jerry was always looking for difference. That's why I did six movies with Jerry. He always applauded the way I wanted to approach things." The approach was fast, loud, bold and action-packed, in a string of hits that included *Top Gun, Beverly Hills Cop II, Days of Thunder, The Last Boy Scout, Crimson Tide, Enemy of the State, Spy Game, Man on Fire* and *The Taking of Pelham 123.* (He's on the set of the 2006 film *Déjà Vu* in this photograph.) Just two days before his death, Scott and Tom Cruise were in Nevada planning for a *Top Gun* sequel. But something, apparently, was wrong in the life of Tony Scott, and he chose to end it.

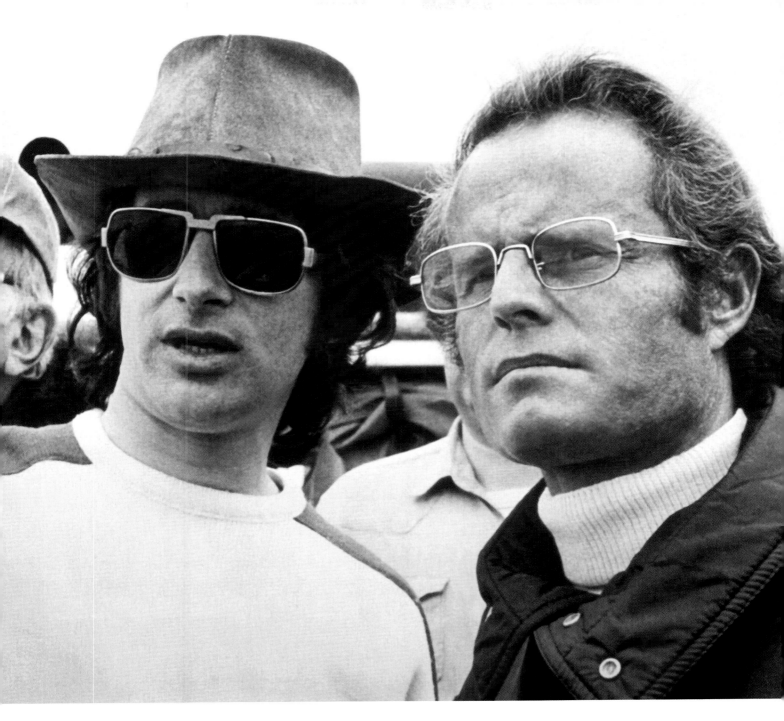

Richard Zanuck

He was born in L.A. into a film family—his mother was the actress Virginia Fox and his father was 20th Century Fox chieftain Darryl F. Zanuck—but that sure didn't help him, not at first. His dad made him head of production at the studio in the 1960s, then fired him after a series of flops. Richard Zanuck entered into a producing partnership with David Brown in 1972, and the duo hit gold with director Steven Spielberg's *Jaws* in 1975 (Spielberg is at left in the photo above). Zanuck and Brown had further great successes with popular fare such as *Cocoon* and classy fare such as *Driving Miss Daisy*, which won them the Academy Award for Best Picture. Later, on his own, Zanuck worked on a half dozen Tim Burton movies, including 2010's megahit *Alice in Wonderland*. Zanuck was born into old-school Hollywood and tried it that way, then was at the vanguard of the new Hollywood. He was 77 when he died.

Ben Gazzara

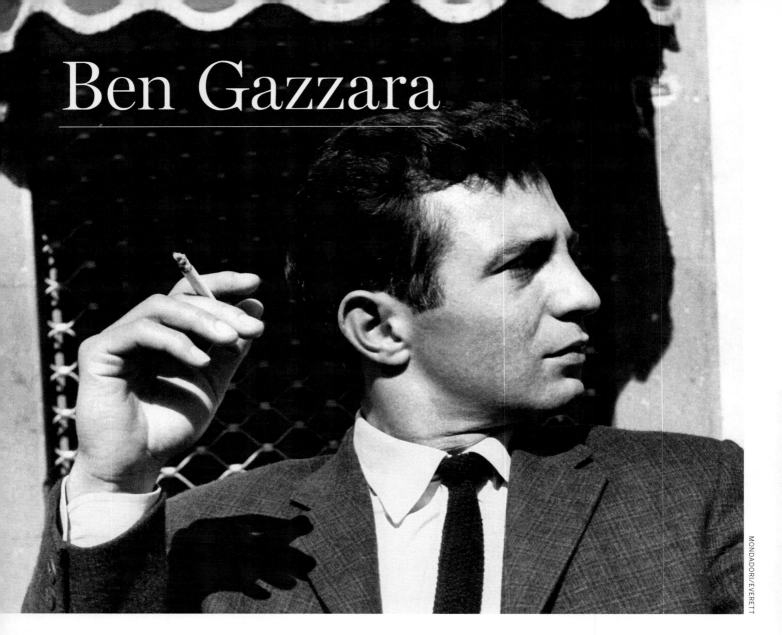

He was born Biagio Anthony Gazzara to Italian immigrants in New York City in 1930, and his prospects were not good. As a boy growing up in Depression-era Manhattan, on warm nights he slept on a fire escape and could hear occasional screams coming from the nearby Bellevue psychiatric hospital. He later said that finding himself in acting was the only thing that saved him from a life of crime. The discovery came, first, in the drama program of the neighborhood boys club. As a young adult he took classes at the New School's Dramatic Workshop and then joined New York's fabled Actors Studio.

Perhaps drawing on memories of his hard-bitten youth, Gazzara (here filming *The Passionate Thief* in Italy in 1960) excelled throughout his long career at playing characters who were both wounded and menacing, and while he never joined the A-list, even the general public recognized him as a serious actor. His career was given fresh life in the late 1990s when a new generation of serious-minded directors discovered the haunting, malaise-ridden films Gazzara had made years earlier with his actor-director buddy John Cassavetes. They offered him work, and Gazzara played a corporate criminal in David Mamet's *The Spanish Prisoner*, a wealthy pornographer in the Coen brothers' *The Big Lebowski* and a mob boss in Spike Lee's *Summer of Sam*. Discovered anew, Gazzara, who died at age 81, was pleased if not surprised. "I was never jealous of another actor," he once told an interviewer, "'cause . . . I knew I had the goods."

Michael Clarke Duncan

As was the case with Gazzara, this actor had a lot of past personal material to work with—and to work through. His father abandoned the family not long after Michael's birth, and he was raised in Chicago by his mother and older sister. He left college to help support them as a ditch digger, a bouncer and even a stripper under the name Black Caesar. When his mom suggested he try acting, he moved to Los Angeles. His burly six-foot-five presence inspired Will Smith, Martin Lawrence and Jamie Foxx to hire him as a bodyguard. This led to minor roles as a bouncer, then a fateful meeting with Bruce Willis. Duncan had landed a relatively small part in the sci-fi adventure *Armageddon*, and on the set he struck up a friendship with the star, who subsequently recommended him for the role of a convicted murderer with miraculous powers in the upcoming adaptation of Stephen King's *The Green Mile*. Duncan was huge in the film—in all senses of the word—and received Oscar and Golden Globe nominations. His voice was as deep and resonant as his physical presence was imposing, but it was also distinctly warm and sweet, and Duncan graced the animated hit movies *Brother Bear* and *Kung Fu Panda* (seen here, recording his *Panda* part in 2008). Duncan was only 54 when he died in Los Angeles from complications after suffering a heart attack.

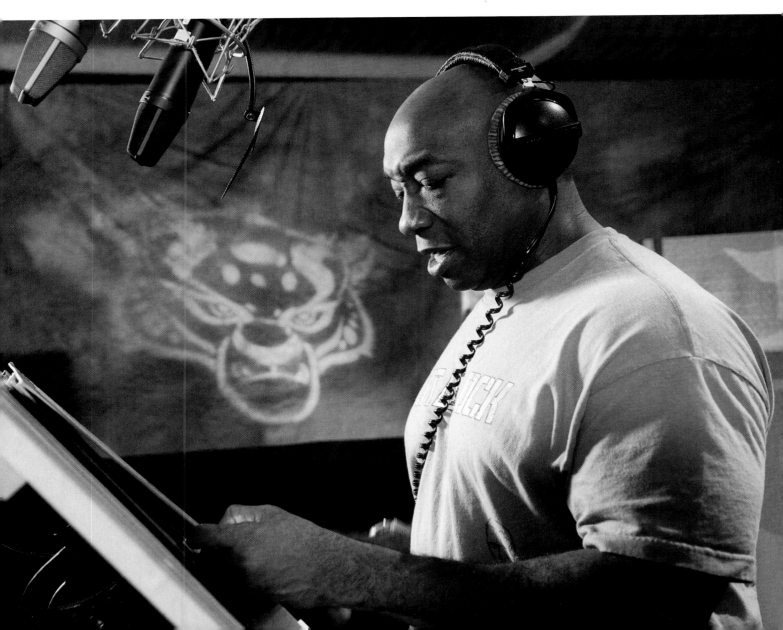

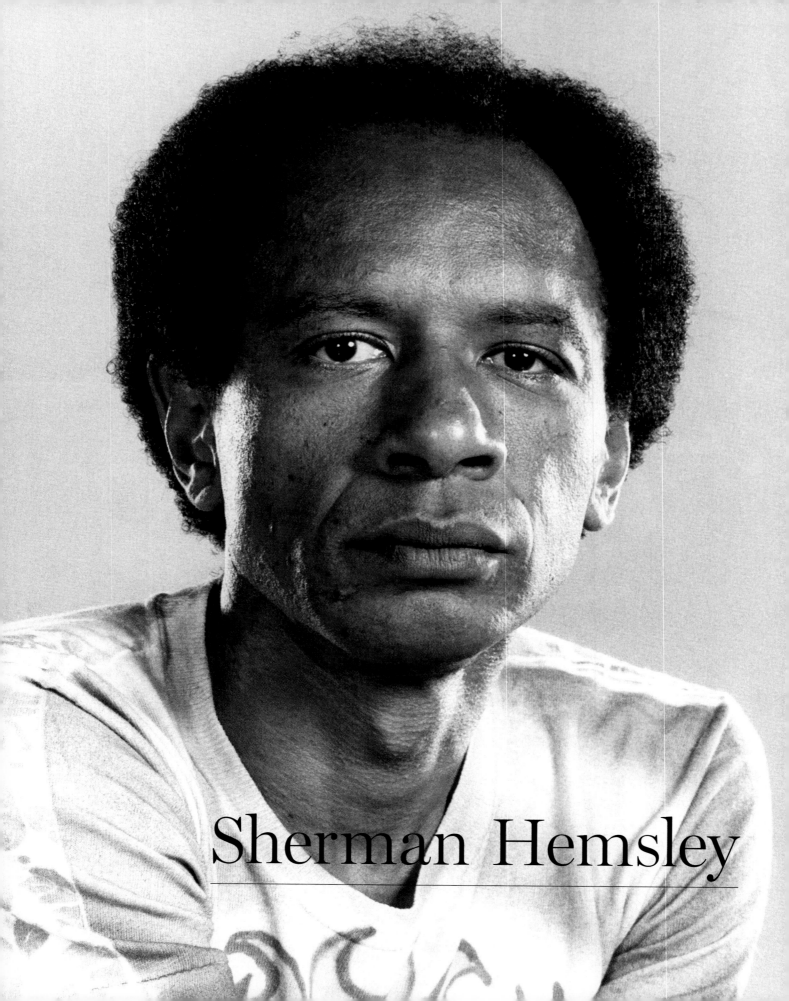

Sherman Hemsley

As was the case with Michael Clarke Duncan, Sherman Alexander Hemsley's father was absent when he was a boy. Hemsley, who grew up in South Philly, dropped out of school in the 10th grade and joined the Air Force, returning home after four years to work for the post office. He, too, like Ben Gazzara and Duncan, found a future through acting. He attended Philadelphia's Academy of Dramatic Arts at night, then continued the pattern—working at the post office to make ends meet, acting in the evenings—in New York City. His breakthrough on Broadway came in the musical *Purlie* in 1970. Norman Lear noticed him and asked him to originate the role of George Jefferson on his new TV comedy *All in the Family*. Hemsley loved the stage and initially balked, then joined the show in 1973. Lear had promised him a second breakthrough—a promise that, over the course of the classic *All in the Family* and a sterling 11-year run for Hemsley's spin-off series *The Jeffersons*, was fulfilled. Hemsley was 74 when he died of cancer in Texas in July.

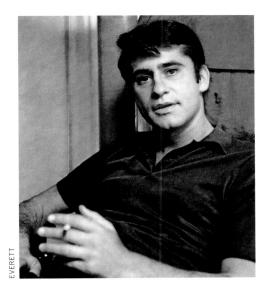

EVERETT

James Farentino

Even when his fellow performers were Bette Davis in *Night of the Iguana* or George Clooney in *ER*, it was often Brooklynite Farentino who drew the eye. He was handsome—he went toe-to-toe with Clooney!—he was dicey, he was dangerous even. The off-screen tumult in his life seemed to reflect that of the intense characters he portrayed. After the actor pleaded no contest in 1994 to stalking ex-girlfriend Tina Sinatra, he was fodder for the late-night TV hosts, given the power of Tina's dad. There were other run-ins with the law and four marriages. He and his fourth wife each filed for divorce at different times, but remained wed until his death in January in Los Angeles at age 73.

Chad Everett

Speaking of the dynamics of marriage: A disgusted Lily Tomlin stormed off *The Dick Cavett Show* in 1972 when Everett— jokingly?—referred to his wife as "my property." Otherwise, the star of TV's *Medical Center* (seen here as Dr. Joe Gannon in 1969) made a career of playing nice. Raymon Lee Cramton was born in South Bend, Indiana, in 1937 and died 75 years later at his home in L.A. of lung cancer. In between, he changed his name, he upset Tomlin, he delighted thousands of mostly female fans on everything from *Maverick* in the early 1960s to *Castle* this year, he was one of Jerry Lewis's frequent cohosts on the muscular dystrophy telethons, he won his own battle with alcoholism, and he was married to actress Shelby Grant for 45 years until her death one year ago.

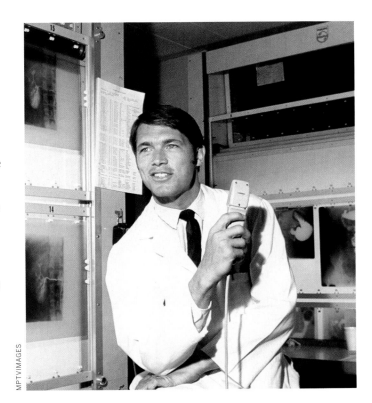

MPTVIMAGES

EVERETT

Tom Davis

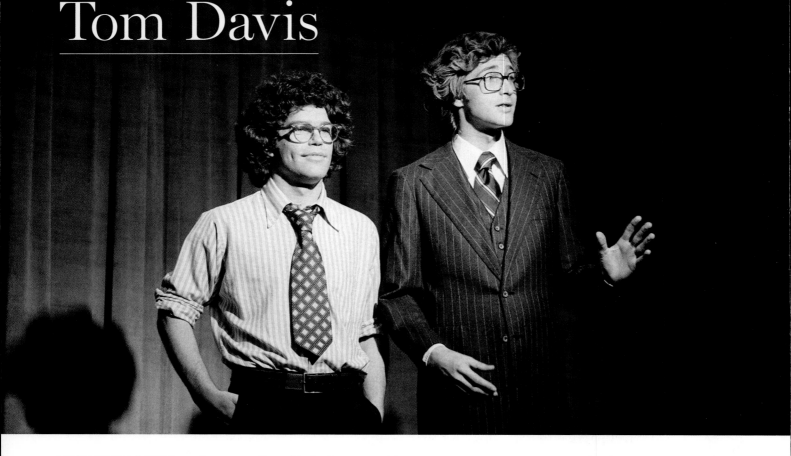

W hen the comedian died of cancer this year at age 59, LIFE approached Al Franken (left), Davis's former partner in mirth, and the Minnesota senator's appreciation follows.

"Tom and I were there on Day One. Lorne Michaels had hired us based on a portfolio of material we put together for a show that didn't exist but that we wanted to exist. That show became *Saturday Night Live,* and it's still going strong today.

"Tom's contribution to *SNL* can in part be measured by the hundreds of sketches he wrote or co-wrote, including classics like the Coneheads, which he created with Dan Aykroyd.

"Dan and I were there with Tom this July at his upstate New York home about 10 days before he 'deanimated'—Tom's word. Tom's humor was always sardonic, but, as you might expect, it was especially sardonic that day.

"We laughed a lot. We reminisced. Danny thought that I was the one who pumped the blood from behind Julia Child's counter in the sketch Tom and I wrote. It was Tom.

"Laughter. When I called Tom's mom after I heard the news, she told me she still cherishes the laughter that came from their basement when we first started writing together in high school. After Tom died, I heard from everyone: *SNL* colleagues, remembering laughs Tom added to their sketches; Minnesotans at the State Fair, recalling laughs that Tom had given them.

"Tom had been diagnosed in early 2009 and given six months to a year. In an essay entitled 'The Dark Side of Death,' Tom wrote, 'I wake up in the morning delighted to be waking up, read, write, watch sports on TV, accepting the fact that in the foreseeable future I will be a dead person. I want to remind you that dead people are people too. There are good dead people and bad dead people. Some of my best friends are dead people. Dead people fought in every war.'

"Tom faced death with grace, courage, and humor. And I miss him."

Robert Hegyes

T he American way of celebrity often smiles upon the young. And sometimes the youthful image is so indelible, or we in the audience so cherish the time, that the celebrity is not allowed to move on, even after he or she has moved on. There's some of that with Franken and Davis, if we consider "Franken & Davis" a unit. There's more of it with the two actors we remember on this page, both of whom caused us to recall the wonderful 1970s sitcom *Welcome Back, Kotter*. After college, the New Jerseyite Hegyes made an auspicious bow on Broadway and was quickly recruited to play one of the high school "Sweathogs" on *Kotter*. When Hegyes died of an apparent heart attack at age 60, those who remembered asked: "Did you hear Epstein died?"

Ron Palillo

L ater in the year, the question became, "Did you hear Horshack died, too?" (In this photo, Hegyes as Juan Epstein is standing, left, interacting with Palillo as Arnold Horshack. Of course that's *Kotter*'s breakout star John Travolta at far left.) Having landed the job on *Kotter*, Ronald Gabriel Paolillo, who had been raised in Connecticut, based the character on his view of himself: "Horshack was the smartest kid in the school," he told *The Miami Herald*. "He was giving up his aptitude in order to be liked. Then and now, that is a very common thing in teenagers." After *Kotter*, Palillo landed a few guest spots on television but endured dry years until he moved to New York, where he joined the cast of the daytime soap *One Life to Live* and worked in theater. He was 63 when he died.

Doris Singleton

American audiences came to love everyone on what was called *"Lucy"*—*I Love Lucy* or *The Lucy Show* or *Here's Lucy* or whatever title it was going by at a given point in time. They loved Lucy, of course, and Ricky and Little Ricky and Fred and Ethel and even the frenemy, Caroline Appleby. When Doris Singleton, who played Appleby in the original show and other characters on the subsequent ones (and who is pictured here in 1953), died at 92 in Los Angeles, the last of the (adult) *Lucy* regulars left the stage.

The plot device was terrific: Caroline was a pain, for instance extolling her son's superiority to Little Ricky, but Lucy always had to bite her tongue because Caroline's husband owned a radio station that could help Ricky senior's musical career. In fact, Lucille Ball and Doris Singleton, who had trained as a ballet dancer and was a popular singer as well, went way back, having met in radio in the 1940s. Singleton was one of those folks who all TV watchers recognized—she guested on everything from *The Dick Van Dyke Show* to *Twilight Zone* to *The Munsters* to *Dynasty*—but they *knew* her from *Lucy*.

And as they did everyone on the *Lucy* shows, they loved her.

Don Grady

Another series on which Doris Singleton had recurring roles—one character in the mid-'60s, a different one in the early '70s—was Fred MacMurray's hit sitcom *My Three Sons*. And so she came into the orbit of a much younger actor who had been wearing big ears as one of TV's original Mouseketeers during the years when she was bedeviling Lucy. Don Louis Agrati was born in 1944 in San Diego, and his mother was a talent agent whose professional name was Mary Grady. Certainly Don's first fame came alongside Mickey Mouse (here, in 1957), then there was further TV work before landing the part, which would last 12 years, on *My Three Sons* in 1960. Grady had a cleft in his chin as MacMurray did, and thought this was perhaps the reason he was cast to play Robbie, one of the sons. Grady evolved, offscreen, into one of America's teen dreams. All along, he preferred music to acting, and was occasionally able to strut his stuff on *My Three Sons:* the show's answer to Ricky Nelson over on *The Adventures of Ozzie and Harriet*. His band the Yellow Balloon had a No. 25 hit in 1967. After the show's long run ended, Grady focused on songwriting and dabbled only occasionally in television. He was 68 when he died of cancer in California.

Phyllis Diller

When the great comedienne died at age 95 in Los Angeles, LIFE asked *Curb Your Enthusiasm*'s Larry David, who we felt shared more than a little attitude with Diller, for his thoughts. As with everything he says—or anything that she ever said—his response was sharp, probably more than a little bit true, subversively humane and of course very, very funny: "Phyllis Diller brought self-deprecation to new heights and influenced an entire generation of people who can't stand themselves. I could never hate myself with so much gusto if Phyllis hadn't paved the way, and for that I am eternally grateful."

A native of Lima, Ohio, Phyllis Ada Driver, born in 1917, was a girl with an artistic bent, and after high school she studied piano at the Sherwood Conservatory of Music in Chicago for three years. (Later and throughout her long life, Diller would find expression not only at the keyboard but also through painting.) In the 1940s, she looked to be following a prescribed path—mother and housewife—after marrying Sherwood Diller who, during the war, worked at a bomber plant in Michigan. When she got a paycheck, it was for writing advertising copy, but by 1952 the family was in California's Bay Area and Diller developed a local radio career that led to her first, 15-minute TV show: *Phyllis Dillis, the Homely Friendmaker.* Diller's stand-up act debuted at San Francisco's famed club the Purple Onion in March 1955 and played for 87 straight weeks.

There were female comics at work in this period, but they were usually pretty or ditzy—or both. Diller was something new and more than a bit brazen, and some male TV stars loved her. Jack Paar booked her several times on his late night show, and Groucho Marx invited her to be a contestant on his quiz show, *You Bet Your Life.*

She was multimedia—every kind of TV program (at left, on *The Ed Sullivan Show* in 1960), recordings, movies—but her role was always herself, even when she was "in character." Once, when she was a mystery guest on *What's My Line,* the blindfolded panel heard that cackling voice and guessed who it was in a nanosecond. There was no mistaking Phyllis Diller, an American original.

CBS PHOTO ARCHIVE/GETTY

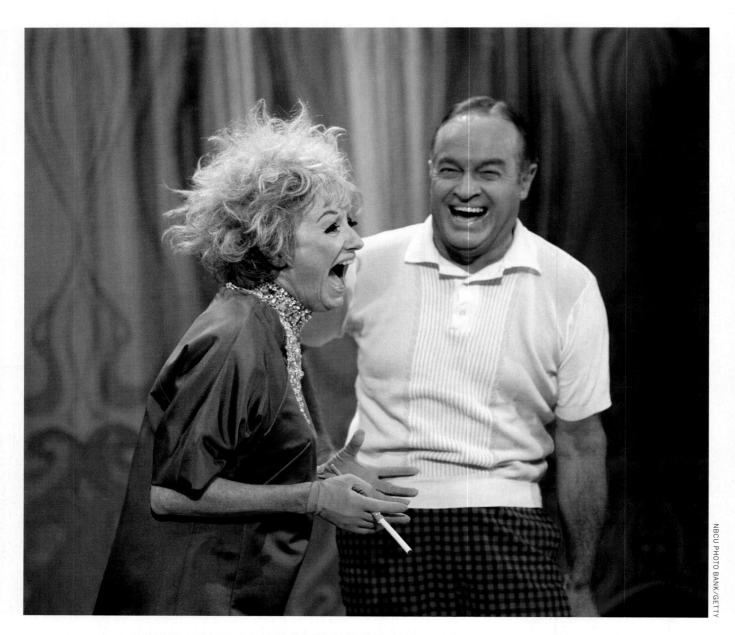

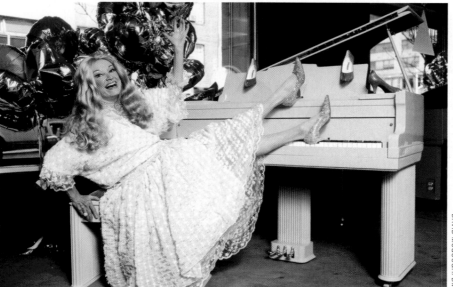

ABOVE, DILLER GUESTS with Bob Hope on *The Kraft Music Hall* show. She credited Hope, one of her biggest fans, with much of her success. She appeared with him on 23 television specials and in three movies in the 1960s, and entertained the troops with Hope's USO outfit at the height of the Vietnam War. Left: Diller at—or on—the piano in 1983; the pose obscures her talent. Opposite: Another variation on the famous pose in 1964.

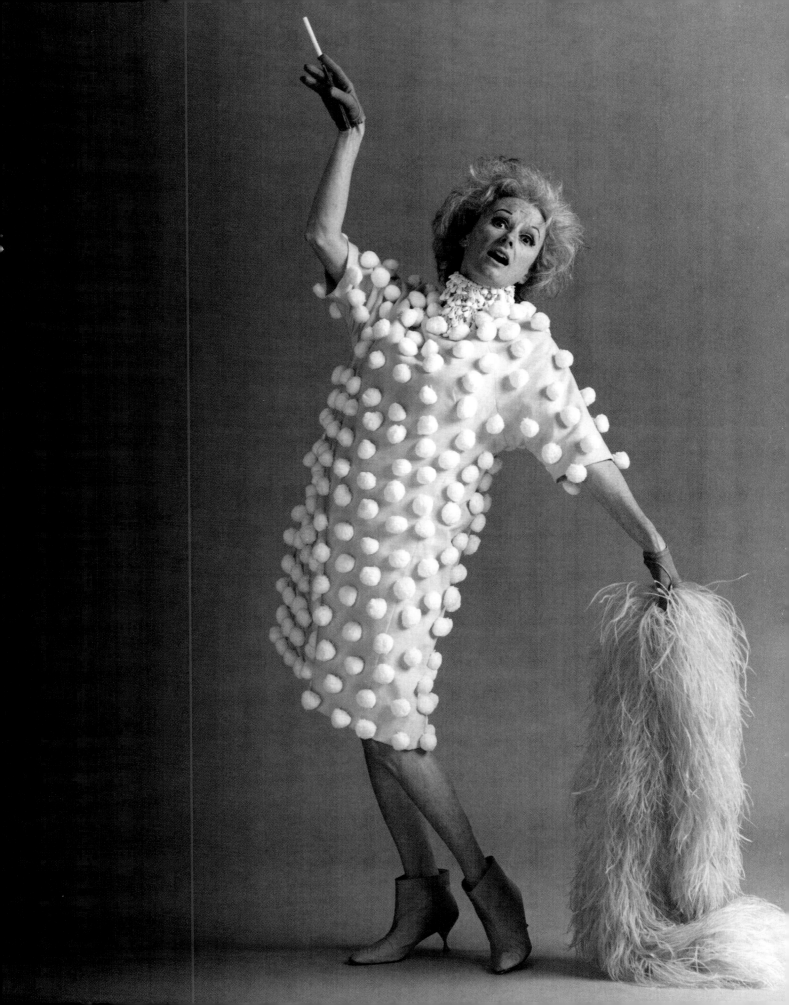

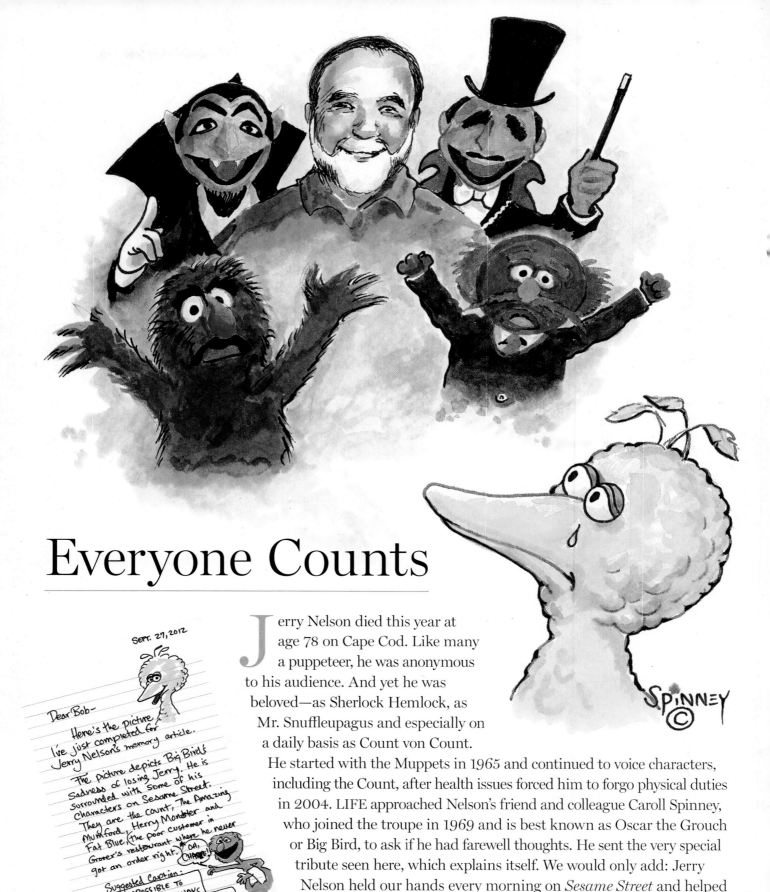

SPINNEY ©

Everyone Counts

SEPT. 27, 2012

Dear Bob—

Here's the picture I've just completed for Jerry Nelson's memory article.

The picture depicts Big Bird's sadness of losing Jerry. He is surrounded with some of his characters on Sesame Street. They are the Count, The Amazing Mumford, Herry Monster and Fat Blue (the poor customer in Grover's restaurant where he never got an order right.) *OA, CHARLIE!*

Suggested Caption:
IT'S IMPOSSIBLE TO COUNT THE MANY WAYS I'M ~~FREE~~ GOING TO MISS YOU. — JERRY NELSON ~~Charlie~~ Debi Spinney BIG BIRD

* We love you and miss you too, Jerry. Caroll and Debi Spinney ➤

(* Oscar made me mess up Charlie's name)

J erry Nelson died this year at age 78 on Cape Cod. Like many a puppeteer, he was anonymous to his audience. And yet he was beloved—as Sherlock Hemlock, as Mr. Snuffleupagus and especially on a daily basis as Count von Count.

He started with the Muppets in 1965 and continued to voice characters, including the Count, after health issues forced him to forgo physical duties in 2004. LIFE approached Nelson's friend and colleague Caroll Spinney, who joined the troupe in 1969 and is best known as Oscar the Grouch or Big Bird, to ask if he had farewell thoughts. He sent the very special tribute seen here, which explains itself. We would only add: Jerry Nelson held our hands every morning on *Sesame Street* and helped us—and our kids, and our grandkids, and our kids' grandkids— grow in life, and learn: an incalculable contribution. You didn't know his name, but that doesn't matter. Everyone counts.